"I'm Here, Now What?!"
An Artist's Survival Guide for NYC!

Amy Harrell

Author Amy Harrell

Cover design by Bethann Mclaughlin Damrath
Chapter title page artwork by Siobhan Harris
Formatting by Sam Pincus
Manufactured in the United States of America

10 9 8 7 6 5 4 3 2 1

ISBN: 1-4196-4480-7

All the information is subject to change. The author has done her best to make all information update and accurate.

Table of Contents

Fame is a vapor, popularity an accident, riches take wings. Only one thing endures and that is character.

-Horace Greeley

This book is dedicated to my father and mother, C.W. Harrell, jr., who encouraged me, in his own way, to take risks and Judith Leigh who kept it all together (although she is not sure where she put it) while I was travelling in many different directions.

Patricia Mauceri-One Life to Live

If we could go back to the beginning of any successful journey, we would soon realize that we didn't succeed on our own. We would see that we could not give all the credit to our God-given talents for having made all the difference when our success hung in the balance and the pendulum could have easily swung in either direction.

Looking back, I am keenly aware that I had resources that drastically affected the outcome. The people we surround ourselves with can greatly influence our direction. We all need some form of helpmate or partner to bring out our best or even to discover where our vision or direction is faulty. In order to have a full and enriched life experience or relationship, we need to connect. It may be friends, teachers, parents, or our church or professional community—but we all need people. I know I was created to be a relational being--for even the book of Genesis tells us, "It is not good for man to be alone". The mutual respect, support and validation that come from these connections are invaluable-often making the difference between success and discouragement-even failure. Our professional lives are no different, and the practical resources in this book will make a challenging journey easier.

Although I have been very blessed to have the career I have had so far, it doesn't seem so long ago when I could only dream about being on Broadway. I could never have imagined some of the experiences I would have. I didn't know I would be performing Shakespeare on Broadway with Christopher Plummer, James Earl Jones and yes, (one of my classmates) Kelsey Grammer. Did I ever think I would stand on the Broadway stage next to Gene Hackman and Richard Dreyfuss at the same time or make a film in Italy with Giancarlo Giannini or DIE HARD with Samuel L. Jackson and again in the soon to be released FREEDOMLAND? I never saw myself creating my own Serafina in one of Tennessee

Williams' best known works. I never dreamed of having the creative input I have in developing my current role as Carlotta on ONE LIFE TO LIVE, which has continued for more than 10 years.

Yes, I have been blessed, but I can still remember my first experiences when I landed in New York City to pursue "my career life". I believed I was given the talent to make it my full-time career and I knew somehow I could make a living; but I wasn't really sure how it would happen. Although I was a native New Yorker, with the dream of becoming a working actress burning in my heart, that didn't exempt me from needing to confront all those scary firsts in a big city. Having lived in the outer boroughs, safely in my parents' care in a residential neighborhood, I was not prepared for what lay ahead.

I remember my first night living in NYC as a student of the Drama Division of the prestigious Juilliard School. It was spent sleeping on the floor in my classmates' room at the "Y" next to her narrow bed. The room was the size of a closet. Not a very glamorous beginning!! But anything can happen in New York. I remember getting home to the "Y" one night (after an exhausting day at school that ended after long hours of rehearsal) only to find that the gate was down and I had been locked out. My roommate forgot to tell me about the 10 pm curfew. I called her from the payphone on the corner of Eighth Avenue and we both cried and then laughed hysterically at our dilemma. She couldn't get out to help me and I couldn't get in. She offered to put every bit of cash she had in an envelope and throw it out the window, hoping we could scrape together enough to get me a room at a nearby hotel. But by midnight one of our other classmates (my angel) arrived home and took me in. Through it all I can tell you the people you meet and the experiences you have, will grow you and you will begin to see that while it is not the easiest choice –it is doable.

I have been fortunate, but it hasn't always been easy. Even as a working actress it's important to know where you can work during the slow times and how you can save money. Knowing

I have been fortunate, but it hasn't always been easy. Even as a working actress it's important to know where you can work during the slow times and how you can save money. Knowing where to go to get a good deal on any item-food, clothing, makeup, home furnishings, resume reproductions or headshots-will put you ahead of the crowd and maybe even help you make the rent. Everything-from finding an apartment, a coach, or a part-time job to make the dream a reality-is exciting and challenging.

No one can do it without being armed with the right tools. But you have already taken an important step toward making those connections by reading this book. I can't recall ever coming across a more comprehensive resource to help in the "survival pursuit" like the one you are about to experience. With the advent of the Internet there are many more resources available—but Amy has targeted the practical do's and directions, mining out the usable and valuable, saving us all a lot of headaches, hours at the computer and trial and error.

Since I met Amy several years ago her heart has truly been to share her God-given talent to confront the difficult, practical areas every artist must face. Amy has taken the time to share what she has learned to make it easier for all of us by offering practical information and solutions. Her delight is to see people succeed and this book will be the helpmate you need. Reading this book will make you feel supported by a friend who has your best interests at heart. My prayer is that you will fulfill your every heart's desire and reach every goal. Persevere and with God's help and the good use of resources such as this one, I know the journey will lead to many successes. Kudos to Amy and remember—you can do it if you believe!

Many blessings,

Patricia Mauceri

MESSAGE TO ARTISTS

Congratulations! You have made a courageous choice to come to New York City. There is no other place like New York City-the city that never sleeps, the "Big Apple" of opportunity, and one of the most exciting places that you will ever live. But let me be honest, this is not an easy town. It is loud, extremely expensive, apartments are small and the competition in the arts is fierce. I know you may be thinking, "I am the best. I am going to make it. I am going to beat the odds and become a huge star." I would never want to discourage anyone for pursuing their dreams and I can't tell you what it takes to be famous, but I can help you with all the practical details of life-finding an apartment, a roommate, finding odd jobs, keeping healthy, economic ways of travel and more-so you that you can get on with what you came here to do-to create your art and share it with the world. Hopefully with "I'm Here, Now What?!" it won't take you 10 years to figure everything out and hopefully it will save you from some of the hardships that I have had. I wish you all the best!

Amy Harrell aka The Resource Girl!

THIS IS HOW I GOT HERE

There have been times in my life when I had everything I needed: a dishwasher, a washer and dryer off the kitchen (I could do my laundry at 11:00 at night, perfect timing for me) and at least 900 square feet. At the same time, I didn't know what I wanted to do. So even with all those *things*, I wasn't happy.

While studying dance religiously every day in Virginia, I saw a flyer to audition for a summer stock theater. After auditioning and getting my first musical, I headed to Elmira, New York to do "The Mark Twain Musical Drama." Though it was difficult leaving my comfort zone, I was doing exactly what I wanted to do and had a passion for. After the show ended it was time for me to explore New York. Unsure about moving there right away, I knew I had to give it a shot and left the comfort zone for the not-so-comfortable zone.

Visiting New York to take dance classes with a friend, I liked it so much I came back a second time and stayed for a week. After auditioning for "Cats" (The European Tour) and not getting it (unfortunately my leg didn't wrap around my head enough times), I auditioned for a children's show at The Little People's Theater Company (Greenwich Village). The director said, "I would love to cast you in my play, but you don't live here." I said, "Oh, don't you worry; I will be here when rehearsal starts on Monday." That was on Wednesday and for two days straight I made hundreds of calls from a pay phone

(these were pre-cell phone days) and left message after message on answering machine after answering machine. Staying at an international youth hostel, I could receive messages on a message board, but no one was returning my calls.

Discouraged and tired I sat down in an Irish pub, ordered some soup and shouted at God, "Okay God, this is my last round of phone calls, you need to make it happen or I am going back to VA!" Frustrated, I went back to the pay phone and realized I had left my purse and backpack at the table. Walking back I said out loud, to no one at all (just think, I didn't even live in NYC and was acting a little crazy, talking to myself): "I can't believe I left my stuff at the table in New York. This isn't Virginia!" Then my prayers were answered. The people next to me, in a very strong Wisconsin accent said, "Hey, we're not from here either. We're here visiting our daughter." Moments later, I learned their daughter was staying in a women's dormitory for temporary living. $550 a month got you two meals a day, a private room and a bathroom on the hall. After interviewing at the dormitory, I had a place to live on Monday. I went back to Virginia to pack enough clothes to last me a couple of months and immediately started rehearsals for "Wilbur, The Christmas Mouse" (where I played a little girl that was very sweet to the mouse that was disturbing her family on Christmas Eve).

This was the beginning of ten adventurous, at times very challenging, years in New York City. I came here not knowing anyone-not a friend nor a relative-and with no advice from anyone. In ten years I have learned many things and I am sharing them with you with the hope that whether you stay

here for six months or for a lifetime, your experience will be as positive as possible. I don't want to mislead you, it's not easy here but with a little help from your virtual friends (like myself), it can be made a lot easier.

I wish you all the best!
The Resource GIRL!

CHAPTER 1

DOING WHAT YOU'RE MEANT TO DO

DOING WHAT YOU'RE MEANT TO DO

There's a special feeling that comes from doing what you are meant to do. You may still have to hike up the mountain of life and occasionally feel the weight of your backpack on your shoulders, but there is a clear momentum, almost like a gentle wind, pushing you forward.

I believe that when you follow your calling, you will find support comes easily and from unexpected places. From the inception of this book I have felt a sense of "this is right" and have had so many people come forward to help me make it happen. All the help and encouragement has spurred me on and provided me with the message: Go for it! This is what you're meant to be doing!

When you are on a path and the obstacles keep coming, at first you may want to make creative choices to work through them. There are other times when there is something inside of us saying the door is slamming, not closing. I believe when we have given something our all and there still isn't any budge, it's a good time to ask others (like a trusted mentor) as well as ourselves some hard but important questions, such as: Can I live without this in my life? Is there something else I could do that I like equally or more than what I'm doing now?

You may be expending tons of energy in many directions and feel it is therefore a waste of time to reflect on your path. After all, there are things to be done and bills to be paid. Yet if you take the time to check in with yourself each week and/or

with a higher power; you will know when you're moving in the direction right for you.

This brings me to the question: Why do we do what we do? While studying at The Royal Academy of Dramatic Art in London, England, I had a very wise teacher named Bardy. We had one-on-one tutorials during which she'd examine my acting work and one day she asked me a question I will never forget: "Does acting feed you?" At first I thought she was asking if the pay I made from acting gave me enough money for groceries and unfortunately the answer was "not for long." However, she was asking a much deeper question: "Does acting feed your soul?" This has been a very instrumental question in my life. When I am on stage, do I feel filled with the joy of what I'm doing? More specifically, I need to ask myself, when I leave the stage, whether I'm paid or not, do I feel like I've done what I was created to do?

If after taking time to ponder these questions you are still not sure about your true path, I highly recommend reading Rilke's "Letters to a Young Poet", a book that helped clarify my artistic direction. In it, the young poet writes Rilke, constantly asking, "Do I have potential? Am I going to be a great poet like you?" Rilke does not answer, instead asking back: "Could you live if you didn't do what you do?"

Now that you know what you want to focus on: What is it going to take to do that? From my experience, I can tell you it's not easy. You are going to need to have great courage, the desire to hustle and you will need to recognize that the life of an artist requires sacrifice.

> Our plans miscarry because they have no aim. When a man does not know what harbour he is making for, no wind is the right wind.
>
> —Marcus Annaeus Seneca

Here is an example of someone doing exactly what they are meant to do...

INTERVIEW: ANN SANDERS
Star of "Avenue Q" and "Beauty and the Beast"

Amy: When you were younger did you have a clear idea of what you wanted to do with your life?

Ann: As a kid I knew I was happiest when I was performing but I didn't initially connect with the idea that I could do it as a job.

Amy: What was some of your beginning training for the performing arts?

Ann: I started by playing the cello. I was always connected to music. Fortunately I had a forward-thinking teacher who had us play more than classical music. He had us play show tunes and even TV show theme songs. He showed us we could use our classical training for different types of music.

Amy: While discovering your talents, where were you living?

Ann: I was living in a suburb near Chicago. However, when I applied for a performing arts school it was in the heart of the city. I was accepted and attended a performing arts high school there.

Amy: How was the performing arts school different from the school you attended before?

Ann: In several ways; one was that in applying I learned there wasn't a string program. I had also begun to have a strong interest in singing at my other school and that became useful as they did have a singing program. I chose that program. Also this school was filled with working professionals and this opened my eyes to acting, dancing and singing as a possible career opportunity.

Amy: After high school, what was your next step?

Ann: I found a school in Texas, Texas Tech, that had a strong voice program with many opportunities to perform. It was recommended to me based on a husband and wife team. This team was very helpful in guiding me and helping me find a direction for my singing. They wanted singers to have a strong foundation so they focused on opera. As they saw that I wasn't enjoying arias, they guided me to sing musicals and other styles. They also encouraged me to take acting and dancing classes. I must say that at this time I felt behind and even did a summer session to do as much as I could to become a "triple-threat."

Amy: What happened when you graduated from college?

Ann: I did regional theatre in Texas. I did a cruise and had the amazing opportunity to see the world. I did other shows and in the middle of all that I also got married.

Amy: I know that this is a personal question, but how has the gypsy lifestyle affected your marriage?

Ann: I am so lucky; my husband has been completely supportive of my career path and continually supports decisions that have encouraged me and my dreams all along the way.

Amy: How did the "Beauty and the Beast" job come to be?

Ann: We were living in North Carolina and I knew the only way I would reach my goals was by going to New York and auditioning. One week we took off to New York City and I auditioned and went back home. I got call backs and was offered a job in Germany. After some deliberation we decided it would be a good move for my career. During that time I met all of the creators of Miss Saigon who also happen to be the creative team for "Beauty and the Beast."

Amy: What advice do you have for young artists?

Ann: I would say that if you love what you are doing keep doing it. I had to learn that I had something to offer the casting directors. Even with my success, I often underrated my talent. Now when I go into an audition I go prepared and with these three thoughts in mind: one, I have something to offer them; two, I know that there will always be more to learn; three, I

have respect for those who are making the decisions as they have more experience than I do. I also want to encourage young artists to enjoy where they are in the process because many times when you make it, you will want to do more and more and more and there are times that you can lose sight of where you have come from and you may lose the joy if you are always looking forward. The drive that got you to success is good but if you can never stop to enjoy it, it's not good. I hope I am being clear. I am searching for this balance myself as I audition for movies and pilots.

Amy: What does the day in the life of a performer on Broadway look like?

Ann: First of all, I just want to say that when you have made it, it is even more important to keep up your top game and that means going to voice lessons each week, going to dance class, going to the gym and taking really good care of yourself. I do all the same things that I did to get here, which also includes talking with agents, sending out headshots and making phone calls. The same thing I did before I was on Broadway is a part of my life now but the stakes are higher.

Amy: Thank you so much for taking time out of your full schedule to share this helpful information. I know that many young artists will learn so much from this interview.

Artists and Their Struggles

When working in an office, one cannot whine or cry about something they don't like to do; there's always the need to have a strong "game face." Many artists do not choose this approach and often share their wide range of emotions, which may be troubling for those around us. (One of my closest friends thinks I'm bipolar because I can be grumpy in the morning and ecstatic by the afternoon.)

In order to create art, you have to be open to using all of your senses. As a result, it is likely you'll be more emotional (in public) than those with more consistent lifestyles (most artists I know do not have a set schedule every week and even if they do, it's subject to change when a new project arises).

A celebrity's life is a great, obvious, example of the tumultuous, emotional life of an artist. The tantrums, drug addictions and divorces, not to mention sexual misconduct, are made public. They are constantly on the go, trying to keep things going. We may not be making the money they are or have the same opportunities, but the drive to make our art and have it be seen and heard is the same. Although the paparazzi are not following us, our friends and family may feel they are watching the drama of a celebrity's life. Hopefully it will not be as dysfunctional as those of the stars, but I have to say from experience that the path of the artist is anything but easy.

Many times it will not appear to others we are on a path. An acquaintance of mine once called the artist's life "ambiguous." I don't like that word because it suggests we are

without focus. I prefer to say we are "ready and willing to be open to spontaneous opportunities as they arise." Open is different from ambiguous, because we want to share and create our art and we're looking for opportunities in which we can do just that.

Struggling is something many young artists do. There will always be people around us who wonder why we haven't quit and moved to an easier town. There will be times when we may in fact feel like quitting. I would like to offer some encouraging words: DO NOT! DO NOT QUIT! We need artists; we need to be challenged to think in new ways.

Courage

If you have come to New York from another state, congratulations, more than likely you are one of the most courageous people that your friends and family will ever know. There really aren't too many other places in America that are as difficult to navigate as New York. I am not talking about the relatively easy streets to navigate, I am talking about finding your place and making it happen. It takes a person with great strength and will power to survive in New York. The idea of rejection must be one that you accept and continue to accept until you find the right place for your art. The concept of "Survival of the Fittest" is alive and well in this town. I believe that if you are reading this book and are already here, then you have what it takes; but if you are in another state or country and are thinking about coming to New York, I say, take the risk, even if it is only for six months. If you have the desire, go for

it and bring all the courage you can find with you; trust me you will need it.

Hustle

The "Hustle" is a popular 70's dance that's fun, fast-paced and, if you are not in shape, will knock your socks off. The hustle I am referring to, however, is of the "making it happen in New York City" variety. Hustling sounds like a negative word but it doesn't have to be. Attacking your days and nights passionately is a hustle. Being ready, looking for opportunities, listening to the voices around you, knowing that someone has what you need to make your dreams come true...those are the positive elements of the hustle. The negatives of the hustle are when you're moving rapidly through a day, always on the go, pursuing anything and everything that comes your way and not knowing what direction you are going in.

If you're acting in a play, you may find yourself rehearsing, working a day job and performing all in the same day. Hustlers are always planting their seed (i.e. sending out headshots/resumes, showing their portfolio, etc.) on many grounds hoping it will take root. It's important for young artists to explore many areas to find the best place to create or present their work. However as you grow older, researching and putting your efforts in one concentrated area could bear more fruit. Knowing what you need to do in one particular artistic effort will give you the focus you need to accomplish your goals. For example, as a dancer, I knew that every day I needed to be in at least two classes, but preferably three. As I

progressed, I concentrated more on jazz and tap than on ballet, as my goal was musical theatre. Ballet, of course, is important for a dancer but the more focused I became the more I knew where to put my energy.

Once you've established your direction, the hustle will be present but in a positive way. It will mean listening at a party for people talking about what you need for your next step. That's the beauty of New York City. You'll find that in every café and restaurant -even at the dog park- people will be there to help you on your path.

Remember: when chasing everything frantically, you may be taken everywhere but where you want to be.

Networking

There is a great need for an artist to go out and meet people, to talk about what you do and what your goals are. You may find people who can help you or even people you can help. But be aware that in New York there will always be a party to attend and if there isn't the balance between working on your craft and networking to meet the right people, you may meet the right people and not be ready to show them what you can do.

Sacrifice

Being an artist takes intense focus. We put so much emphasis on our art that we may let the rest of our lives slide into disarray. The artist's life often involves a lot of sacrifice, which is not to say that other professions don't. The difference is that an artist's sacrifices aren't limited to several years of schooling and there is no set end result, such as a lasting career and/or a six-figure income. This "business" is unpredictable, tumultuous and requires incredible stamina and perseverance.

But just how much can we sacrifice for what we do? When we see a baseball player with a bandaged knee we know that his playing this sport is a driving force that far outweighs the pain of that knee. This can and does apply to many dancers. On stage you do not see their aches and pains but backstage there are various physical therapists (massage, chiropractic, etc.) and at times painkillers to literally keep them on their toes.

It's important to ask yourself: What are you willing to sacrifice? What artistic gift calls you to lead a life that you sacrifice so much for? The answers will be different for each artist, as will the perception of what is and isn't a sacrifice. Some people feel so "called" to be an artist that they associate this path with fulfillment, not sacrifice. Others will consciously, constantly struggle with all they feel they're giving up to pursue their dreams.

MY ARTISTIC DIRECTION

Everyday I am amazed with all the talented people I meet here in New York City. If someone plays the piano, they probably play three other instruments just as well. Sometimes we need to clarify where we will put our creative energy. Where do we see the most growth possibility? (think: limited time and fierce competition)

What do I love to do and would do, even if no one ever paid me a dime for doing it?

What do I do that makes time elongate and brings me peace in the process?

What would I spend a year doing, if I had no other responsibilities?

What did I want to be as a small child?

The next time you are in a conversation take note of the things you talk about that make you smile.

"Like a flute playing lightly in the distance, dreams are the music of tomorrow's love song."

- Yuroz The Artist

INTERVIEW: JULIET TAYLOR
Woody Allen's Casting Director

Amy: Thank you for taking time today. I know you are a very busy lady and have been for some time now. One of the reasons for writing my book is to learn about what success is, what people do who are really successful. I like to read books by those people and I like to talk to people who have wisdom and knowledge in that area. That is why I am so pleased that I have the opportunity to talk to you today.

First of all, I wanted to ask you if your journey was a straight one; did you always want to be a casting director?

Juliet: Daydreamed about being in the theatre, acting...did tons of theatre at Smith College but when it came to auditioning, I just didn't have the nerve, maybe didn't feel I had the talent. I studied American History. Fortunately, Smith had a board of counselors so you had mentors, we took field trips with this group and we saw "Cabaret." After the show, there was a question and answer period. During that time, one of the people was a casting director and they explained what they did. I thought that sounded interesting. Upon graduation (in 1967), I moved to New York and I got a job working in production and ended up working with David Merrick, a prominent theatre director. This was a way to be involved in the world of theatre without doing the auditioning. After working with him, (in

1968), I went on to be a secretary for the much-sought-after-for-many-years casting director Marion Dougherty. During my time there, the mayor made it possible for more films to be shot here. There was a lot of work to be done and when Marion went off to cast films in 1973, I ran her company until 1978 when I went off to cast films independently.

Amy: Now that you have been doing this for many years, what suggestions would you give young actors?
Juliet: I feel that New York has always had a very serious group of actors that has always been better trained than those in L.A. The training is a very positive step for every actor.

Amy: What is something that you see young actors doing that is negative for their career?
Juliet: One thing that is a negative today is when actors are demanding. In the 60's and 70's, during a time of constant partying and drug usage, there was more tolerating of diva-like and demanding personalities. Now, there is less tolerance of this behavior. And another negative would be: there are still people who are having a fantasy or daydream about being an actor based on their looks or their personality. Sometimes these people will have something that they can do and can achieve some level with that one thing, but when it comes to sustaining a career and/or a diversified one, that would be more difficult without training.

Amy: Would you cast someone if you knew that they had/or have a reputation of being difficult?

Juliet: It definitely affects my decision in casting if I know someone is difficult.

Amy: Do you have any advice that you would like to give about the ideas of stardom or the realities of stardom and/or longevity regardless if you are a star or not? I guess what I am asking is this: You are around stars frequently. What can a younger artist learn from those stars (since more than likely they won't be around stars initially but will be around their fellow actors trying to figure everything out)?

Juliet: The actor needs to think about perception versus reality. You have to go into this business because you love to act. Don't go into acting to be a star, because you will be disappointed. It's hard work. The wheel turns constantly and you are successful one day and not the next. Very few will remain successful. You need to be really in love with it and be willing to take the rejection and blows in this profession. Another real difference about young actors today and young actors thirty years ago is that when actors came to New York they accepted they would be living the bohemian life/modest lifestyle. It was accepted that that was part of the sacrifice needed to make art here. Also, while they were living this bohemian life they also were talking about their art, they weren't talking about making money at their art. They knew that it would take time to do that, but that wasn't their focus, their conversation.

New York and L.A. were very separate people/actors. TV people in L.A. were very interested in bringing people from New York to L.A. There was an exodus thirty years ago where "big deal" people out in New York went out to L.A. to make money and they did. However, I saw some very gifted, talented people lose the quality of their work. Some may look at the money and not see it as a sacrifice. From my point of view, it really looked like they lost something in order to make money, but people make their own choices.

Amy: What do you think differentiates a star from another talented performer? Do you have any ideas about how one person pops out and becomes a superstar and how someone who has been working as long or has been doing similar pursuits does not? Do you contribute it to fate/luck? Are there disciplines or attitudes one can incorporate in their life to promote a positive path towards this road of stardom and success?

Juliet: Magic, charisma – they immediately draw you in. It's totally intuitive for me. You can sense something immediately when they come in. I know before they say anything if I am interested in them or not. One thing that I notice about those people, who come across my path that are doing well in this business, is their confidence. I do not see people without confidence and charisma; these two things are positive and are instrumental in being successful in this business.

Let me give you an example. When Meryl Streep came into town, it didn't take five minutes for the whole town to know that she was here. She had a rare, deep well to draw from and it made everyone in town want to cast her. We immediately knew that she was something special. People would say to me that it was amazing that I was the first one to cast her in her first movie; they said it like it was something that I did. Everyone in town wanted that opportunity and I was just lucky enough to get that opportunity.

Amy: How important do you think networking is in the life of the performer? From TV, it would appear that these people on TV and in movies are out every single night, 365 days a year. Do you think this constant being in the limelight secures their stardom or causes someone to reach stardom?

Juliet: I don't really like the word networking, because if you are networking just to meet people and you don't have anything to back up or to show the people that you are meeting, I think it is a waste of time. However, networking in the organic sense of doing all you can by working on student films, independent films and doing plays whenever, wherever you can is great for the actor. This networking is good and necessary.

Amy: Is it possible for someone to have a successful acting career without constantly meeting new people at parties?

Juliet: Absolutely.

Amy: Having worked up close and personal with many stars, it appears that many people who have success in their careers are never very successful in their personal lives. Do you see any reason for this disconnect between being super-successful in one area and having apparent failure in another?

Juliet: Actors' personalities, by nature, have large egos or have egos in place. Undaunted by getting rejected, your reality shifts and becomes unreal; it becomes surreal. You can demand anything [as a star] at any age. Few people have success in this area [personal relationships]. There are a lot of actors who are dysfunctional.

Juliet Taylor has worked with highly acclaimed directors such as Steven Spielberg, Woody Allen, Martin Scorsese, Nora Ephron and more. She has worked with Woody Allen since "Love and Death" and more recently on "Schindler's List," "The Birdcage," "Primary Colors" and "Meet Joe Black." (information provided by Filmmaker's Index)

After profusely thanking her for her invaluable insights, Juliet Taylor wished me luck and took off for her next appointment.

"I beg you...to have patience with everything unresolved in your heart and try to love the questions themselves as if they were locked rooms or books written in a very foreign language. Don't search for the answers, which could not be given you now, because you would not be able to live them. And the point is, to live everything. Live the questions now. Perhaps then, someday far in the future, you will gradually, without even noticing it, live your way into the answer..."

-Rainer Maria Rilke

CHAPTER 2

MOVING TO NEW YORK CITY

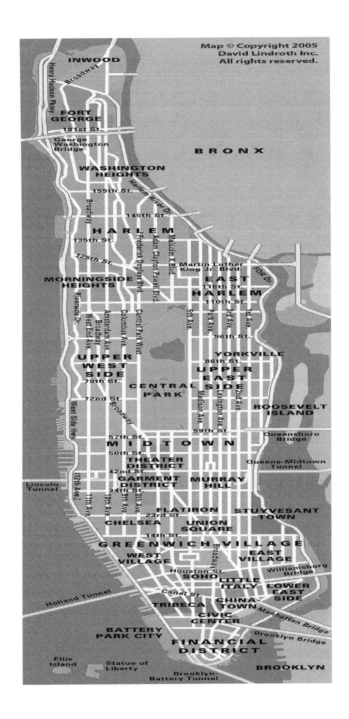

MOVING TO NEW YORK CITY

If you are not yet living in New York City but are planning to move here, let me tell you: whether you come for a summer, a year or a lifetime, you will never be the same. Living in NYC is much like spending a college semester abroad; it's unlike any other American city. The diversity of cultures, languages, careers and energies is unparalleled and makes for a life-changing experience.

In 1985 (some of you might not have even been born yet!), I was dreaming of coming to New York for a summer of nanny work, but my boyfriend at the time didn't want me to leave. I listened to him, went to college and my life continued on, but somewhere in my mind the New York seed was planted and I longed to go. I finally made the move in 1993 and have never regretted the decision. This city has challenged me and made me a stronger person in so many ways; it would take a second book to capture all the ways I have changed and grown.

There are things I wish I had known when I was making my move. That being said, here are a few words of advice:

1. Save six months living expenses.

2. Sell your car! Public transportation is the way to go here.

3. Have friends or relatives living here? Ask them for tips.

4. Sell everything you don't need. Storage units are a waste of money.

5. Clear up personal and financial problems before you get here.

6. Contact teachers, ask them for advice.

7. Get clear on your reasons for moving here.

"New York is where the future comes to audition."
-Ed Koch

<u>Things to do before you get here</u>

1.
2.
3.
4.
5.
6.
7.
8.
9.
10.
11.
12.
13.
14.
15.
16.
17.
18.
19.
20.

FIND A ROOMMATE/LIVING SPACE

So you're here, you need a place to live, and you're asking yourself: "I'm Here, Now What?!" You will need to consider what location will best meet your needs, the pros/cons of living alone vs. with strangers or close friends and of course, the all-consuming issue of what you can afford.

First off, ask yourself these important questions:

- What is my price range?
- Where do I need to live and what do I need to be close to?
- Do I need a simple place just for sleeping or space to create?
- Do I have to live in Manhattan or can I live in one of the other boroughs (Staten Island, The Bronx, Queens and Brooklyn)?
- Do I need a place where I can have a pet?
- Do I want to live alone or with a roommate?

These questions and others will help you focus on the location and essentials that will make your living experience in New York City the best it can possibly be. Keep in mind that many things about living and renting here will be different from doing the same somewhere else.

I came to the city with stars in my eyes and dreams of an apartment with a view, a terrace, a fireplace, elevator, doorman and laundry in the building. After looking at several apartments, I realized how lucky I was when I finally found a place with good light, elevator, laundry and a person to take packages and give me my mail. It is rent controlled as well. Many places in New York are walk-ups, have no laundry facilities, and are definitely without a doorperson.

Oftentimes, in New York, reality and the dream about the place we have in mind do not coincide. We might find the space we crave but it is an hour away on the train. Therefore, we need to figure out our priorities: Is proximity to places we need to be more important than space? I had always wanted to live on the Upper West Side, but for $2000 a month for a studio, it was not worth it. I found a one bedroom, under $1300 (a real bargain in New York City) in Midtown, surrounded by everything I needed. Many promotional jobs and auditions are in my neighborhood. Talent agents are in walking distance, although it can feel like they are a million miles away when I cannot get them to respond! I can even do all my errands within a four-block radius. During my diligent pursuit of an acting/dancing career, this location has been perfect and much better suited to my needs than a more expensive uptown apartment.

If you are thinking of moving here or have just arrived in NYC, the chart shows examples of what apartments go for in various Manhattan neighborhoods. There are also very specific books available detailing each neighborhood by price, safety and

demographic (whether family-friendly or strictly for the bohemian at heart).

I recommend <u>If You're Thinking of Living in...All About 115 Great Neighborhoods in and Around New York</u>, by Michael Leahy.

Typical Cost of Manhattan Apartments

	Upper West Side	Upper East Side	Midtown	Downtown
Studio	$1,934	$1,781	$2,114	$2,192
1 BDR	$2,852	$2,779	$2,862	$2,928

Source: Corcoran Year End Report (2005)

If you have decided that renting an apartment is the right choice for you, this interview will prepare you for the process.

Interview with Lee Zuniss, Real Estate Agent with Citi Habitats

Amy: What got you interested in becoming a real estate agent?
Lee: I wanted a job that provided flexibility and got me in touch with the people I would like to help. I am also a Certified Feng Shui Consultant and know that I can help people moving into a New York apartment make it a healthy space.

Amy: When people come from other places to rent in New York, how can they best prepare to rent an apartment in one of the most difficult –if not the *most* difficult- places to rent an apartment?

Lee: Here is a list of the things you need to have ready:

-a letter of employment on company letterhead that lists your yearly salary
-your most recent pay stubs
-your most recent bank statement
-copies of 1040s from your previous tax year
-photo ID (passport or license)

It is also a good idea to have a letter from your last place of residence and other business references that would show you are responsible. You need to know up front that most landlords want you to make 40 times your monthly rent. Therefore, if your rent is $1500 per month you need to make at least $60,000 per year.

Amy: What if someone has bad credit or does not have a 9-5 job?

Lee: You will need to have a family member or close friend to act as your guarantor [someone who signs the lease and will be responsible to pay the rent if the tenant cannot]. The guarantor needs everything on the list that I mentioned before,

and they have to make 80 times the rent per month. Therefore, if the rent is $1500 per month they will need to make $120,000 per year. It is better if the guarantor lives in the tri-state area [New York, New Jersey or Connecticut] but a good broker will know what buildings will work with people who have guarantors from other states.

Amy: What if someone is working part-time or as a freelancer and does not have a guarantor? What can this person do to find a place to live?

Lee: Try to provide whatever you can from the first list, but know that it will be very difficult to rent an apartment. I suggest that you go to www.craigslist.org, click on New York, and go to the section for roommates/shares. Many people already have their name on the lease and you will not have to put your name on it. You will more than likely need to provide at least one month's rent as a security deposit, but there won't be a broker's fee. [In New York, if you use a real estate agent, you often need to pay a fee – usually 15% of the yearly rent]. Another thing to do is to ask your broker if they know about private owners that are renting. Often, private owners will be more flexible about renting to part-time/freelance people. They will interview the person. They will look at their references and the letter from their last place of residence.

Lee: No, there are opportunities to find much cheaper rents in the other boroughs – Brooklyn, Queens, The Bronx and Staten Island.

Amy: When is the best time to search for an apartment?
Lee: Summer is the best time to look. It is much easier to move in the summer than in the dead of winter.

Amy: This has been great. Are there any other ways people can save money in this market?
Lee: With the economic climate not being that strong and many people losing their jobs, many owners of buildings are offering to pay the broker's fee instead of the tenant-to-be having to pay for it. Make sure to ask your broker to find rent-stabilized or rent-controlled apartments. Every year, the government votes on the percentage the rent can increase. In addition, some owners are offering one to three months free rent as an incentive to come into their building. This often happens in new buildings in order to ensure total occupancy. An informed broker will know the buildings that are offering these concessions. (As time moves further and further away from the tragedy of September 11th, there are fewer and fewer incentives offered.)

Amy: Lee, thank you for your time.
Lee Zuniss, call 1-917-751-9033

Roommates

Considering the high costs of renting an apartment and some of the requirements, when you first move to New York, sharing a space may be your best bet. It is easier to get out of a short-term roommate share than a yearlong lease.

ROOMMATE PROS:
1. You will save money sharing an apartment.
2. If your roommate has already lived here for a while, he/she can educate you about the city.
3. Your roommate might become a good friend.
4. You can meet other people through your roommate.
5. The city can be lonely, try finding a roommate who shares some of your interests.

ROOMMATE CONS:
1. Living with a fellow artist can be tricky as there is potential for pettiness and jealousy.
2. If your lifestyle patterns are too different, there could be problems.
3. Communication is challenging enough with good friends, and if you room with someone you don't know and they aren't willing to talk about house rules in a friendly, courteous way, it will not be a pleasant place to live.

> "There would be no society if living together depended upon understanding each other."
>
> -Eric Hoffer

Roommate Websites:

www.roommatefinders.com
www.roommates.com
www.sublet.com
www.sublets.com
www.cityleases.com
www.metroroommates.com

Most roommates/shares websites require a one to three month fee or a larger flat fee (such as $300 for Roommate Finders). Be sure to read the fine print before giving your credit card information!

> "Life is hard, living together shouldn't be."
>
> -Adam Schachter

Roommate Survey

QUESTIONS YES NO

Do you smoke?
Do you have a pet?
Do you stay up late?
Do you get up early?
Do you like to have parties?
Will your friends and family come to stay?
Are you looking for a friend or just a roommate?
Do you want to share food?
Do you want to decorate together?
Do you drink? If so, a little or a lot?
Is cable TV important to you?
Are you a neat freak or a slob, or somewhere in the middle?
What do you think about having boyfriends/girlfriends over?
How many phone lines do we need? Do you have a computer? Will you use a cell phone or get a 'land line'?
What would be your ideal living situation?
If one of us is unhappy about something, how would you like to work out the problem? Do you want to talk over dinner, write a note, etc.?

"What do we live for, if it is not to make life less difficult to each other?"
 -George Eliot

THE CONMAN COMETH

One summer, I was assistant directing a play in the basement of the Holy Cross Church, across the street from the Port Authority Bus Terminal. During rehearsal one night, a young woman entered the church looking for a helping hand.

"I am from Germany," she told us, "and I have lost my parents and my grandparents. Fortunately, because one of my parents was an American, I have an American passport and will be able to start receiving welfare. I need a place to stay over the weekend. On Monday, I will go to Social Services to begin the welfare process. I have nowhere to go."

She asked if anyone could take her in for the weekend. As I looked around the room, I was shocked and amazed to see the others ignoring her. Here we were doing a church play; I truly expected the members to be more compassionate. Having an extra bed in my room, I extended an offer. That next day, several of us spent time at a street fair, and I gave the young woman money for food. A red flag flashed in my mind when she began looking at earrings, but I did not say anything considering all the stress she was under.

Later that evening I made her some pasta with balsamic vinegar sauce (one of the few things I can cook). She grimaced as she took her first bite and proclaimed, "I don't like this!" It was difficult to believe that someone in such dire straits would be so picky and impolite.

The following night I had dinner plans with one of my "crushes" and since she had nowhere to go, I made the mistake of inviting her. She dominated the discussion with very deep and disturbing topics. Some of what she mentioned needed to be discussed but not when you first meet someone. Disturbed and disappointed I tried to remain calm as I considered her desperate situation. However, I was sad as I saw this "crush" very infrequently and she ruined our evening.

Monday was the day she was to take all her paperwork to Social Services, but when I awoke, she was gone and had left all her documents on the bed. Finding that peculiar, I looked through her stuff and found numerous airplane tickets (she had told me she had only been to the U.S. once, many years ago), a phone bill from Ohio, and a Petland discount card. Things were not adding up. It became clear she had conned me and it felt horrible. Moreover, to make matters worse, I had a roommate and had to tell her I had allowed a con artist to sleep in our apartment. My roommate had had over thirty roommates in eleven years and fortunately for me, was not upset since nothing of ours had been stolen.

Furious and disappointed in mankind, I bagged up the woman's food, documents and attached a note saying, "I don't appreciate you taking advantage of me. Here's your stuff, and I don't ever want to hear from you again." Fortunately, I was only out about thirty dollars.

New York is a place where you can have wonderful experiences, but is also a place that tends to attract and/or breed misfits and the maligned.

Housing (For Women Only)

Sacred Heart Residence
432 W. 20th Street
NY, NY 10011
tel: 1-212-929-5790
www.sacredheartresidence.com
rates: $240/week
info: Short-term residence (up to two months) for young women (ages 18-28) and includes two meals a day. There is a curfew of 11:00 PM on weekdays and midnight on weekends.

Jeanne D'Arc Home
253 W. 24th Street
NY, NY 10011
tel: 1-212-989-5952
rates: $350-$560
info: for women (ages 18-40), double room or single room, no curfew

Webster Apartments
419 W. 34th Street
NY, NY 10001
tel: 1-212-967-9000
www.websterapartments.org
rates: $220 per week for interns/students
info: For working women only, this residence offers two meals daily, a communal bathroom, maid service and linens.

Centro Maria
539 W. 54th Street
tel: 1-212-757-6989
e-mail: cenmariany@mindspring.com
rates: $180/week (single), $160/week (double), $155/week (triple)
info: Residence is for (ages 18-29) and serves two meals a day. The curfew is 11:30 PM during the week and 12 am weekends.

Parkside Evangeline
18 Gramercy Park South @120th street
NY, NY 10003
tel: 1-212-677-6200
e-mail:parkside@parkresidence.com
rates: under 8 weeks-$75 a day, after 8 weeks-$40 a day
info: Residence for (ages 18-35) serves two meals a day and requires minimum three-month stay during the school year, minimum month-long stay during the summer, no curfew.

The Salvation Army Markle Residence
123 W. 13th Street
NY, NY 10011
tel: 1-212-242-2400
salvationarmyny.org/housing/markle/contact.htm
rates: $1,082-1,099/month (single), $764-866/month (double), $666/month (triple), $654/month (quadruple)
info: For women 18 and up, the West Village residence serves two meals a day and provides maid service and linens.

The Christopher
212 W. 24th Street
tel: 1-646-485-3809
rates/info: go to
http://www.commonground.org/housing/chelsea/index.asp
This is an outstanding resource for people with low-income as
well as those living with a chronic illness, such as HIV/AIDS.

Aurora
475 W.57th Street
NY, NY 10019
tel: (212) 262-4502
auroaintake@commonground.org
A great place for people who are in the arts: you cannot make
less than 15,000 and you cannot make more than 26,000.

Other ways to find a place to live:

- The Village Voice Free Paper
- Go to www.craigslist.org and click on "New York City"
- University dormitories sometimes offer rooms for rent.
- The Screen Actors Guild Bulletin Board (at 360 Madison Avenue,
 12th Floor) 1-212-944-1030.
- Downtown incentives due to September 11th, 2002
 Alliance for Downtown New York
 120 Broadway, Suite 3340
 tel: 1-212-835-2773

THE JOY OF BEING CLUTTER-FREE

One of the biggest challenges of living in New York City is the issue of space, or rather the lack of space. If you are living in the apartment you inherited from your great-great-grandfather and are paying seventy-five dollars a month for rent, feel free to skip this section.

Having grown up in a house, I find that even after ten years of city living, I have never fully adjusted to the limitations of life in a tiny space. I was used to being able to create an art project in the garage, cook a meal in a separate kitchen (mine is on the wall in the living room, and until recently when you opened the oven door it would hit the end of my couch!) or host a party of ten comfortably. However, an even greater problem for me is that my family has always had an abundance of *stuff*. The term "pack rat" does not even begin to describe us. Yes, there are things we have let go of at garage sales, but there is plenty that our sentimental hearts cannot bear to part with.

While preparing to leave Virginia and move to New York, I struggled with what to take to New York. On the way out, I picked up my favorite plastic horse from my large collection. If I had had a large space to move to, I would have taken all fifty-plus. Having always wanted a horse, I see my plastic version as a physical mantra to remind myself of that dream. I share this in empathy for those of you who hold onto every sentimental item, keep brochures from every trip, mementos from friends,

relatives and ex-boyfriends/girlfriends. In New York, housing all of these excessive doodads can lead to insanity, made worse if you are sharing a space with another doodad collector.

It is great to be surrounded by special mementos that are memory provoking and inspirational. Nevertheless, if we are inundated with things, if everywhere we look our minds are pulled in many directions, we will not have the mental space (as well as physical space) to focus on our art. I know many creative people who do not throw things away, as they see artistic potential in almost everything. I completely understand, but having ten different muses occupying your space at once will leave you feeling scattered and unfocused. An idea: choose one or two projects and send the others to a "vacation spot" (storage) for a while.

I have been learning to practice what I preach and have cleared out much of my excess clutter and feel so much freedom, mentally and spiritually.

"When we are authentic, when we keep our spaces simple, simply beautiful living takes place."

-Alexandra Stoddard

Suggestions for Clearing Clutter:

1. Toss, "re-gift" or donate presents that you do not like or for which you do not have room.

2. Take inventory of items you have in duplicate. Keep your favorite and share the others.

3. If it is difficult to release items, here are some questions to ask yourself or to have a friend ask you. She/he will not be emotionally attached and can help give you perspective in the letting go process.

 - When will you use this?
 - Why are you saving this?
 - When are you planning to do this project?
 - Is this something that you can donate?
 - Are you ever going to fix this?
 - Could you lend this to one of your friends?
 - Is this something you could sell on Ebay/Amazon/Craigslist?
 - Could you take it to a storage unit?*

*Tip: A word about storage units: I would suggest only renting one if you know you are going to be moving into a larger space in the near future. Even the small units cost about $50 a month, which equals $600 a year. You have to ask yourself if what is inside the storage unit is even worth that much?

4. Be realistic with yourself. Will you really learn karate, Russian and the art of origami from books, DVDs and videos within the next few years?

5. Go to a seminar at the Learning Annex on eliminating clutter or buy a book on the subject (such as <u>The New Messies Manual: The Procrastinator's Guide to Good Housekeeping</u>, by Sandra Felton)

You may be wondering what removing clutter from your life has to do with becoming a happier artist. Here is what I have learned:

1. Removing clutter frees your mind to focus on your art.

2. We have limited space and when we fill it with things we love, it makes it a happier place.

3. When we are disorganized, we often buy something we already have because we cannot find it. Getting organized saves us money.

4. Many artists are dreamers and might buy something for a future house or future project. Focus on your life now.

Simple Life, Simple Needs

When I watch great artists at work, I notice how few things they need in their creation process. An ice skater is wearing skates; a cellist has his cello, a painter his paint and canvas. They do not need anything else to create their art. Theater actors may have sets surrounding them, but many plays have been made without backdrops and props.

Artists bring themselves, their talent and instrument to their "canvas" of choice. So why, as human beings, do we invest our time, energy and money into things that clutter our minds and spaces, and suck life from us?

Mother Teresa had a very special purpose on this earth. She was here to show the love of God to the poor, to be an example of God's love in action. What possessions did she have? I have heard that she wore her sandals until they fell apart. I am not suggesting that being an artist is akin to sainthood, but when we know our purpose, how is it we are still entangled with "props" that are lifeless and often create debt?

"Practice simplicity and contentment. We all consume lots of time buying and maintaining things. But if we had fewer possessions, we would have less to take care of. Recognize that unnecessary possessions are stealers of divine time. Everyday we are given eternal significance – to serve, to love, to pray, but we squander our time on things that will soon leave us forever."

-Focus on the Family

Get the Mattress Off the Floor and Live a Little!

You came here with a dream, maybe to be the next Julia Roberts (or at least receive her $20 million paycheck) or to sell one of your paintings in a famous gallery. Who wouldn't want those things? I know I dream about owning a beautiful home where I can throw lavish parties, and have my friends over to swim in my luxurious pool with a cascading waterfall.

It is so important to have huge dreams, and yet –and I say this without a drop of pessimism– not all of us will reach the proverbial "golden carrot." Looking around me, I see extremely talented people living sparingly in tiny apartments, waiting for that big break. The reality is that we will not all make it to the top, so we might as well try to live as comfortably as possible.

When I first came to New York to pursue dancing and acting, I was happy to sleep on a mattress on the floor. I did not want to "settle in" when I was sure I'd be moving to the bigger, better apartment very quickly, due to my amazing star-studded status. As time went on and I realized I wasn't going to be an overnight success and that Prince Charming was probably still painting his stallion white, so I decided I had better get my mattress off the floor and live a little.

Don't we deserve a peaceful place to recharge our batteries after we have spent the whole day giving the world everything we have? I bought a very expensive bed, complete with a luxurious mattress (I believe there are some things we should not scrimp on) and have never once given it a second thought. I sleep amazingly in this bed, and learned I cannot wait for something to happen in the future in order to live each day to the fullest.

CHAPTER 3

THE BEAUTY AND FREEDOM OF ODD JOBS

THE BEAUTY AND FREEDOM OF
"ODD JOBS"

Upon arriving in New York City, most artists discover that working at their craft does not initially bring financial security. While some will one day reap the benefits from "paying their dues*," it is important to realize other artists may create their art simply for the love of it and not for a big, fat paycheck. No matter what lies in your future, in the meantime, you still have to eat and pay the rent.

They do not call me the "Resource Girl" for nothing. With an abundance of "odd job" resources and experiences, I have had the pleasure of helping countless people (myself included) find new and different ways of generating income while waiting for that big break. Having experienced so many different types of jobs, I can give you the inside scoop on which are fun and lucrative.

This chapter explores a wide variety of ways you can support yourself, from one-hour focus groups to long-term office jobs. Read on, and find the "odd job" formula that best suits your personality and financial needs.

"The master in the art of living makes little distinction between his work and his play, his labor and his leisure, his mind and his body, his information and his recreation, his life and his religion. He hardly knows which is which. He simply pursues his vision of excellence at whatever he does, leaving others to decide whether he is working or playing. To him, he's always doing both."
-James Michener

Focus Groups/Surveys/Market Research

Companies love to advertise. They hope that you will watch said advertisement, be struck with consumer fever and buy their brand. So, how do they know who is interested in what? One of the ways they determine what we want to buy is by talking to us "up close and personal." This is where focus groups come in.

A focus group typically involves ten or more people in a room to discuss the product at hand. Sometimes the group will be given an assignment, such as creating a new slogan, or will be asked to provide feedback on the brand and its current marketing direction.

On top of being paid in the $100 range for 1-3 hours of your time, you will be fed and might even preview a product before it is released to the public. I particularly enjoy focus groups as I have been blessed with "The Incredible Gift of Gab" and always feel relieved to have a forum in which to use it.

A great place to find focus groups is the "etcetera jobs" section of www.craigslist.org (click on "New York").

* "Paying your dues," i.e. putting in tons of effort, often for a lengthy period, in pursuit of your goals (such as internships and apprenticeships). At first, you do not perceive that you are receiving benefits until the day you get that big break and reap the rewards of time and energy spent.

Focus Group Contacts

Novasel tel: 1-718-591-7736 email:jnovasel@aol.com	JRA Marketing and Research tel: 1-800-355-3395
Focus Point Plus INC tel: 1-212-675-0142 email: focusplus@msn.com	Betty Diesel tel: 1-516-867-6600 www.greatopinions.com
Brain Reserves tel: 1-212-772-7778	A La Carte tel: 1-516-364-4004
Global Strategies tel: 1-212-260-8813	Focus Room tel: 1-914-428-2727
Knowledge Systems & Research tel: 1-800-645-5469	W.A.C. tel: 1-212-725-8840
Schlesinger tel: 1-732-906-2074	Bruce Goldman tel: 1-718-823-9873
April tel: 1-212-972-9072	Anna Perez tel: 1-718-438-8661
Nancy R. Sohn tel: 1-914-723-2299	

After you have found a focus group/market research company, simply call and ask to become part of their database. If they are interested in having you join, they will ask you all kinds of questions, some general and some very specific, like how much money you make, your age and where you live. Do not worry about giving this information away as they have hundreds of other people just like you in their database.

When something comes up that fits your demographic, they will call you and ask questions to further pinpoint whether you are the right person for that particular group. They usually do not want actors, so if you are an actor but also do desktop publishing, present yourself as a desktop publisher. Most artists wear many different hats. However, if they need surgeons and you do not happen to be one, don't lie.

One last point: these companies do not want focus group "groupies" so there is no need to share with them how many groups you have done.

Surveys

While focus groups always pay for your time, online surveys often want to get your opinions for free. Please do not waste your time on those, as there are surveys that will compensate you for participating. If you have time, you could fill some out for fun, but only if they are willing to send you coupons, discounts or other incentives.

Focus Group/Survey Websites:

www.advancedfocus.com www.faithpopcorn.com

www.focusfwd.com www.focusgroups.com

www.focusroom.com www.greatopinions.com

www.myfocusgroup.com www.surveys.com

Time is money and money is time. Don't waste it on free surveys.

Suggested Search Engine Words:

"market research"
"focus groups"
"surveys for money"
"market research surveys"
"cash for opinions"

"Your profession is not what brings home your paycheck. Your profession is what you were put on earth to do, with such passion and such intensity that it becomes spiritual in calling."
 -Vincent Van Gogh

Trade Shows

New York City, like many other large cities, draws people from across the nation and around the world to shop at the "World's Bazaar." The Jacob Javits Center, W. 34th Street and 12th Avenue (1-212-216-2000), is where most of these conventions are held.

Each show has a concentration, ranging from fashion and jewelry to cars and boats. Though smaller shows run about a hundred booths, there are typically several hundred.

All of the booths need people to sell, demonstrate or educate the buyer about the products. I work about fifteen days a year as a trade show model, basically becoming a temporary representative of whichever company and products I am assigned. Most of the time, unless the buyers ask, they assume that I work full time with that company: an assumption that is important to uphold. The more you love and appreciate the product while you are working, the better the chances of your being asked back (and you will most certainly sell more).

Tradeshows sometimes provide opportunities to act, to dance and to sing. A car or cosmetic company might have ten sexy performers singing and dancing about their product to entertain and educate the consumer. However, these job opportunities often come directly from talent agents, so if you do not have representation, pick up the Ross Reports.
You can find this resource at the Drama Book Shop at:
250 W. 40th Street, 1-212-944-0595.

Another type of popular trade show is the Toy Fair, held in various offices of toy companies around the city. This NYC event draws buyers from around the world to check out the latest toys. To find out more information about Toy Fairs, check out Backstage or call the companies directly to find out which agents will be submitting for the Toy Fair auditions (the Toy Fairs are always in February). Then, send those agents your headshots and resumes. Many times the performers that are chosen for these jobs are the performers that most resemble the toys being demonstrated. For example, if you are tall, thin and have big blue eyes, you might be asked to demonstrate the new Barbie™. Likewise, a very small, petite person could be well suited for any number of costumed characters, i.e. a Power Puff Girl™.

Here's the skinny on making money at trade shows. The fees vary, but I do not think anyone should work below $200 a day (it will be offered, so stand your ground...or do it once at the offering price for the experience. Remember, if you try it out for a low fee and do a great job, you can always ask for more money the next time). $200-250 is perfect for a normal trade show day, while a Toy Fair will usually yield more than $250. If you are dancing or singing, the pay should be much higher.

Trade Show Contacts:

CTI Conventions Staffing
331 Madison Avenue
New York, NY 10017
tel: 1-800-700-7053
tel: 1-212-297-1288
email: conventions@cti-group.com
website: www.cti-group.com

Live Marketing
1201 North Clark, suite 201
Chicago,Il 60610
tel: 1-312-787-4800
email: info@livemarketing.com
website: www.livemarketing.com

➢ global connections

Ambassador Talent Agents
333 North Michigan Avenue, Suite 910
Chicago, IL 60601
tel: 1-312-641-3491
infoline: 1-312-409-4429

Productions Plus
30600 Telegraph Road
Suite 2156
Birmingham, MI 48025
tel: 1-800-437-9815
email: JFiddler@productions-plus.com
website: www.productions-plus.com

Judy Venn & Associates
3186 Airway Avenue
Costa Mesa, CA 92626
tel: 1-800-553-8855
website: www.judyvenn.com

Suggested Search Engine Words:

"tradeshow models"
"spokesmodels"
"dancing/singing industrials"

Note: Remember that just because the company is located in California, it does not mean that they do not work with people in NY. Some companies are bi-coastal and some book nationwide. It is best to reach out to as many companies as you can so you are on multiple lists.

Clinical Trials and Medical Research

I am hesitant to include this category, as it involves potential danger. If you ever choose to do a clinical study, I strongly recommend that you talk to your doctor before taking any medicine or participate in any study.

Clinical trials are research vehicles that pharmaceutical companies and universities use to test the effectiveness of particular drugs in treating various symptoms and diseases. Having done their major research on animals or in laboratories, they are looking for people who are willing to be guinea pigs.

Essentially, these trials are controlled studies, giving medicine to some participants and placebos (sugar pills) to others. From there, they monitor the results (or lack thereof) for days, weeks or months.

I do not participate in clinical trials involving medicine, as I am into prevention and thankfully do not have any chronic medical problems. I am aware that there are people who have tried everything to treat their diseases and are willing to take a risk.

The type of trials I *am* willing to participate in are the ones that simply involve questions and answers. After finding out detailed information of your condition, they will have you take tests and possibly perform tasks before or during times when you are experiencing the symptoms of your condition. This part of the clinical trial process does not involve medicine.

You are your own person and need to make the decision that is right for you, but as someone who sees you as a virtual

friend, I recommend asking questions about side effects and talking to your doctor before participating in any drug studies. (author/publisher takes no responsibility in regards to the results)

Clinical Trial Contacts:

Clinical Trials
email: registry@clinicaltrials.com
website: www.clinicaltrials.com

National Research Group
2020 Pennsylvania Avenue, PMB 866
Washington, DC 20006
tel: 1-202-728-3833

"Mystery Shopping"

This "odd job" is a particular favorite of mine, as there is the potential to have fun. Here's the basic concept: You enter a store and no one knows that you are coming to assess the service, the attendants, the general tidiness and any other area that needs to be observed. You'll take mental notes that you will later fill out on a questionnaire. Often times you will be assigned to buy an item and return it later or you might be given certain questions to ask the attendants to test their product knowledge.

I have "mystery shopped" for some great places, like upscale designer shops that I would never have walked into otherwise. One plus of mystery shopping is that it is a flexible job, and one minus is that you need self-control when shopping where you normally would not.

Once I went off the deep end and bought a skirt that was the price of a weekend vacation. Shopping in a very upscale designer store, I was overcome by the excitement of it all. The salespeople were very attentive and the clothes were unbelievably beautiful. Know your limitations, because the pay for secret shopping is about $10-35 per shop. (For the payment you receive, you could not buy a pair of socks in some of these stores.)

If you get several offers to "mystery shop" within a similar time frame, try to do them all in one day so that it becomes a more profitable investment of your time.

"Mystery Shopping" Contacts:

Beyond Hello
P.O. Box 5240
Madison, WI 53705
website: www.beyondhello.com

Companies on-line (pay for info, Buyer Beware!!)

www.betterbusinessratings.org/shopping
www.mysteryshopping.com
www.shoppingjobshere.com,
www.mysteryshopperservice.com,

Suggested Search Engine Words:

"mystery shopping"
"get paid to shop"

Dog Walking

This one is self-explanatory; you go to people's homes and walk their dogs. Next time you are at the park and see someone being pulled by ten dogs, just think; that harried animal lover could be you (references needed)!

You can put up signs on bus stops, poles, college campus bulletin boards, etc. The work is not difficult and you can expect to earn $15 and up per hour.

Waiting Tables

Every artist I know who has come to New York has been a waiter, is a waiter or has considered becoming a waiter. Restaurants are a mainstay of NYC culture, regardless of what the economy is doing.

Most people say that you need experience to be a waiter in a NYC restaurant, but I know that if you are persistent you will find work. It might not be a five-star restaurant the first time around, but you will find something to pay the rent.

I have worked for two different restaurants and found it was not my cup of tea. I spent too much time chatting with customers and just couldn't seem to keep all that info swirling around in my head at once: 5 minutes on the hot chocolate, 15 minutes on his meal, 7 minutes on hers, and so on...

Tennessee Williams moved to New York in the late 1930's. After working as an elevator operator, waiter and usher, his first play "The Glass Menagerie" was produced on Broadway in 1945.

Catering

This is similar to waiting tables, except you generally get paid a lot more. There are also cool perks that include going to large parties in the Hamptons and rubbing elbows with the rich and famous as you serve them their lobster.

Catering is the type of job in which you need to know someone with experience in order to learn proper serving techniques. It is necessary to know on which side to serve the drinks, the meat, etc.

You can make $150-200 per night, and that might be for only five hours of work. Keep in mind, though, that you are on your feet all night!

Interview: Paul Neuman of Neuman & Bogdonoff Catering

Amy: How do young artists get started in the catering business?
Paul: Primarily, we work with referrals from people who have worked with us in the past. We like referrals, however if someone is eager to do catering then they just need to introduce themselves to catering companies and be willing to start at the bottom.

Amy: Once you have accepted them, how do they begin the work process?
Paul: We partner them with an experienced caterer, and they follow behind the person. Generally speaking, they will begin with a very simple event where they will be serving sodas.
Amy: What will be the next step for a caterer?

Paul: The key to progressing and learning the techniques, such as bartending and French service, is doing many, many events. Our staff is comprised of young, very bright artists and one of their strengths is their intense focus. They need to thrive in a high-energy environment and keep that high energy focused throughout the night. As they progress, they may wish to take a bartending class outside of the work they do with us.

Amy: What are some of the different types of jobs they can do?
Paul: They can be part of the kitchen staff that sets the tables, preps the food and scrapes the dishes. Sometimes there are multiple kitchens and they may be in charge of the entrée kitchen or the dessert kitchen. Others will be on the floor serving the whole night. Some will be bartenders and serve drinks.

Amy: What is the income possibility?
Paul: The starting pay is great at $15-17 an hour, but as you learn the skills and become a key player in our team, one of the bartender captains or primary kitchen captains can eventually make $30 an hour.

Amy: What are some of the venues you cater to?
Paul: We cater to corporate venues, all the way from delivering lunchtime meals to their large corporate events. We also do other high-end venues.

Amy: Thank you for your time, Mr. Neuman. I know that this information will help many young artists for years to come.
Neuman & Bogdonoff tel: 1-212-228-2444

Temporary/Office Work

If you just graduated from college, you have all the skills you need to jump into office work and start making at least $15 an hour. In addition, if you have special skills in the computer world, such as web design, you can make upwards of $25 an hour.

These jobs can be ideal, as there is the potential for longer-term assignments that would allow you to save up and take a few weeks off to focus on your art. If you do want a permanent 9-5 gig, many times the temporary position will transition into a permanent one.

Note that these jobs require that you acquire some office attire. I have not one suit in my closet, but I do possess some grays and blacks that are appropriate for a corporate environment. The eclectic clothing that reflects your artistic personality would be best saved for a film festival or art show.

Some of the temporary companies will provide training, while others will not. However, if you are reading this book right out of school, I can't imagine you would have any problem with office computer skills: Word, Power Point and Excel are essentials for office work.

Temporary Agency Contacts

Taylor Hodson, Inc. 133 W. 19th Street New York, NY 10011 tel: 1-212-924-8300 fax: 1-212-924-1503 www.taylorhodson.com	Lloyd Staffing 58 W. 40th Street, 14th Floor New York, NY 10018 tel: 1-212-354-8787 fax: 1-212-354-8920 www.lloydstaffing.com
Segue Staffing 295 Madison Avenue New York, NY 10017 tel: 1-212-696-5898 fax: 1-212-986-2913 resume@seguestaffing.com www.seguesearch.com	Swing Shift, Inc. 1 Horatio Street New York, NY 10014 tel: 1-866-833-4473 fax: 1-212-727-9754 info_ny@swing-shift.com www.swing-shift.com
Kaye Personnel 1868 Route 70 Cherry Hill, NJ 08003 tel: 1-856-489-1200 fax: 1-856-489-1010 info@kayepersonnel.com www.kayepersonnel.com	The Tempositions Group of Companies 420 Lexington Avenue, Suite 2100 New York, NY 10170 tel: 1-212-490-7400 fax: 1-212-867-1759 nyinfo@tempositions.com www.tempositions.com

To say there are too many agencies to list is a grand understatement. There are dozens upon dozens listed in any Yellow Pages, so you'll have to make calls to scout out the right ones for you, your skills and your interests.

Teaching

Whatever you do best is a great potential moneymaker. Here are a few examples of how you can put your skills to work for you:

- If you are a singer and have a piano or keyboard in your apartment, you have everything you need to start giving voice lessons or coaching sessions. Don't worry if you are not a Broadway star. In New York, you can find amazing teachers and just so-so teachers, but if you know how to read music, play the piano and have a genuine desire to teach others what you know, you are fully prepared to begin.

- Dancers can rent a studio (see list below), put up flyers on posts around the city and start teaching at a charge of $14-18 per ninety-minute class. If you would prefer to be working alongside other professionals, then I recommend submitting your resumes to community centers, acting schools, dance schools and music schools. You might need to start as a substitute teacher until an opening becomes available.

Dance Studio Contacts

Flamenco Latino Studios 250 W. 54th Street, 4th Floor New York, NY 10019 tel: 1-212-399-8519	New Dance Group Studio 254 W. 47th Street New York, NY 10036 tel: 1-212-719-2733 www.ndg.org
Broadway Dance Center 221 W. 57th Street, 5th Floor New York, NY 10019 tel: 1-212-582-9304 info@bwydance.com www.bwydance.com	Eighth Avenue Studios 939 8th Avenue New York, NY 10019 tel: 1-212-397-1313 tel: 1-212-799-5433 www.ripleygrier.com

A Special Dancer's Prayer

It is God who arms me with strength and makes my way perfect.
He makes my feet like the feet of a deer; he enables me to stand on the heights.
He trains my feet for battle; my arms can bend a bow of bronze.
You give me your shield of victory, and your right hand sustains me,
You stoop down to make me great.
You broaden the path beneath me, so that my ankles do not turn.

-Psalm 18:32-36

- There are many other ways that dancers can make money in between musicals or when their company is on break. Many of these opportunities utilize dance talents, (i.e. weddings, birthday parties, bar/bat mitzvahs) teaching people line dances like "The Electric Slide" or entertaining party guests with show choreography. The pay can range between $75-250 for a night, depending on the event and company. I once danced for a baby's first birthday party, a celebration that cost the parents at least $25,000! Le Masquerade is a great company for these jobs (www.lemasquerade.com/1-800-666-7260).

- If you are an actor and have studied at a conservatory, there may be techniques you can share with actors that have had a more eclectic training experience. I know many actors that have a great ear for accents, but if you studied the international phonetic technique for learning an accent, you have a highly marketable skill to teach. Another possibility: If you have a talent for improvisation or comedy, get a group of your friends together and experiment with all of your collective ideas. From this gathering an acting method or school may develop. Getting the word out is as easy as putting up flyers around the town.

Seminars

If you haven't yet found a regular space for teaching, seminars are a great way to go. I highly recommend The Learning Annex, an excellent venue for sharing your particular gifts. The free Learning Annex magazines, available all over the city, mean free advertising for you.

Here is what you do: write a proposal about what you will be teaching, what your background is, why you are the best person to teach this subject, and give a sample outline of the class. Be persistent, as they have many people proposing classes. The arts are a very popular topic in New York.

There are always schools looking for guest speakers. If you live in New York, people in the Midwest will think you are a star on that basis alone. The line "if I can make it there, I'll make it anywhere" carries weight!

Seminar Contacts:

The Learning Annex	SLC Conference Center
16 E. 53rd Street, 4th floor	352 7th Avenue, 16th Floor
New York, NY 10022	New York, NY 10001
tel: 1-212-371-0280	tel: 1-212-244-8888
www.learningannex.com	www.slccenters.com

Promotional Work

I could easily write an entire chapter on promotional jobs alone. This type of work, from my experience, is an excellent way to make good money while keeping an open, flexible schedule.

Companies have many different ways of promoting their products, from street fairs to trade shows, shopping mall demonstrations to character costumes at events. These promotions involve introducing and educating people about new products, and keeping existing products in the mind of the consumer.

They look for perky, upbeat, clean-cut people to work the promos, usually within the 18-30 year old age range. While there are jobs for "older" folks, this is definitely a youth-oriented industry. If your age falls above the range but you look younger, then state your age range, not your age, to the promotional companies.

I recently worked a group promotion for Listerine™, a well-established company looking to advertise their Listerine Cool Mint Pocket Packs™ breath fresheners that instantly dissolve on the tongue. At times we did "guerilla marketing," where the company would say, for example: "Go to Times Square on New Year's Eve and hand out the product to everyone you see." If you are a people-person, events like these are fun and festive (you can make great money working on holidays, i.e. $25 per hour).

All promotions are different, but usually you can make $15-20 per hour. There are higher paying jobs that involve alcohol, where the pay is $25-55 an hour (the higher numbers involve being a manager).

Flexibility is high, because the companies know they are primarily working with artists and that sometimes you'll be free and sometimes you won't. As long as you do the jobs to which you've committed, work with a positive attitude and arrive on time, they will use you for future promotions.

In order to be considered for promotional work with any of the following companies, you'll need to mail or email (depending on the company) a resume, photo and cover letter detailing your promotional/trade show experience.

Promotional Contacts:

Estro Entertainment
Steve Estro
tel: 1-201-206-5779
fax: 1-877-881-7201
steveestro@estroentertainment.com

Renegade Marketing Group
75 Ninth Avenue, 4th floor
NY, NY 10011
tel: 1-646-486-7700
jconnell@renegademarketing.com
www.renegademarketing.com

The Rose Agency
2215 N. Beachwood Drive, Suite 101
Hollywood Hills, CA 90068
tel: 1-323-461-ROSE
website: http://rosemodels.com

> ➤ primarily trade show work, emphasis on hair shows

Very Special Events
11440 West Bernardo Court, Suite 168
San Diego, CA 92127
tel: 1-858-485-1171
fax: 1-858-485-0389
email: cindy@veryspecialevents.com
website: www.veryspecialevents.com

> ➤ This company is one of my favorites. They are very organized, and pay well and on time. I particularly like that many of their events are educational and humanitarian in nature, such as the recent program I worked in which I spoke with people about breast cancer treatments.

Haus Promotions
tel: 1-888-4promotions
email: email@hauspromotions.com
www.hauspromotions.com

Big Orange Productions
93 Dana Street
Providence, RI 02906
tel: 1-401-273-9768
fax: 1-401-273-9763
email: talent@bigorangeproductions.com
website: www.bigorangeproductions.com

➢ promotions, primarily on the East Coast

Event Pro
9000 Keystone Crossing, Suite 650
Indianapolis, IN 46240
tel: 1-317-580-0006
email: info@eventpro.com
website: www.eventpro.com

Interference, Inc.
611 Broadway, Suite 819
New York, NY 10012
tel: 1-212-995-8553
email: info@interference.com
website: www.interferenceinc.com

➢ guerrilla marketing, promotions, some trade show work

Encore Nationwide
2772 Artesia Blvd, Suite 204
Redondo Beach, CA 90278
tel: 1-866-GET-STAFF
fax: 1-310-793-9242
email: hgettings@encorenationwide.com
website: www.encorenationwide.com

➢ This is also one of my favorite companies, as they provide steady work all year long. If you are on time and up beat, they will keep you busy. Thanks Heather!

It's a Gas Marketing
1182 Fischer Blvd.
Toms River, NJ 08753
tel: 1-732-929-0456
email: scott@itsagas.net
website: www.itsagas.net

➢ promotions for the music industry

Deep Marketing
2453 W. 6th Street
Los Angeles, CA 90057
tel: 1-213-385-5454
fax: 1-213-385-5656
website: www.deepmarketing.com

A.D.D. Marketing
6600 Lexington Avenue
Los Angeles, CA 90038
tel: 1-323-790-0500
fax: 1-323-790-0240
website: www.addmarketing.com

The Marlin Entertainment Group
1720 Post Road East
Westport, CT 06880
tel: 1-203-255-6100 x 28
email: neal@marlinent.com
website: www.marlinent.com

Best Faces of Chicago
1152 North LaSalle, Suite F
Chicago, IL 60610
tel: 1-312-944-3009
email: bestfaceschicago@aol.com
website: www.bestfacesofchicago.com

The Hart Agency
1140 Broadway, Suite 1506
New York, NY 10001
tel: 1-212-989-4288
fax: 1-212-481-2839
website: www.hartmodel.com

GMR Marketing
220 E. 42nd Street, 15th Floor
New York, NY 10017
tel: 1-212-505-3636
website: www.gmrmarketing.com

> music, sports and mobile marketing; national promotional tours

Alloy, Inc. Headquarters
151 W. 26th Street, 11th Floor
New York, NY 10001
tel: 1-212-244-4307
fax: 1-212-244-4311
website: www.360youth.com

> This company promotes products to kids

Gail & Rice Productions
21301 Civic Center Drive
Southfield, MI 48076
tel: 1-248-799-5000
fax: 1-248-759-5001
email: info@gail-rice.com
website: www.gail-rice.com

Dazzling Stars
8700 Old Hartford Road, Suite 305
Baltimore, Maryland 21234
tel: 1-410-668-6110
www.dazzlingstars.com

> ➤ acting, modeling, promotions

Splash Marketing Group
P.O. Box 284
Ponte Vedra Beach, Florida 32204
website: www.splashmarketinggroup.com

> ➤ alcohol promotions

TSE Staffing
196 Triumph Drive
Atlanta, Georgia 30327
tel: 1-404-350-0010
fax: 1-404-350-0466
website: www.tsestaffing.com

Red Peg Marketing
website: www.redpegmarketing.com
tel: 1-703-519-9000

On-Point Marketing
website: www.onpoint-marketing.com
email: support@onpointmarketing.com

Pierce Promotions and Event Management
123 Free street
Portland, Maine 04101
tel: 1-800-298-8582
website: www.pierceevents.com

Event Pro Strategies
Three Tingle Alley, suite b-c
Ashville, NC 28801
tel: 1-828-254-5261 x 318
fax: 1-828-254-8741
website: www.eventprostrategies.com

Patrick Talent Agency
P.O. Box 951
Connellsville, PA 15425
tel: 1-888-840-5448
fax: 1-724-626-3343
website: www.patricktalent.com

J Williams Agency
2004 Macy Dr.
Roswell, GA 30076
tel: 1-770-518-0078/1-770-518-3018
website: www.jwilliamsagency.com

CMP Models
1126 Porter Street
Philadelphia, PA 19148
tel: 1-215-755-6611
fax: 1-215-755-6613
website: www.cmpmodels.com

Glo Promotions
400 Lafayette Street
New York, NY 10012
tel: 1-212-675-8445
website: www.glopromotions.com

> an event company promoting clubs and parties

Axis Models & Talent
PO Box 367
Ringwood, NJ 07456
tel: 1-973-248-8040
email: axismodelstalent@yahoo.com

> trade shows, fashion models and "real people" models

On Track Modeling
4401 East Independence Blvd., suite 203
Charlotte, NC 28207
tel: 1-704-536-4040
website: www.alphamodelgroup.com

On Your Mark Productions
tel: 1-732-381-0318
website: www.oymp.net

MP Media & Promotions
10608 Flickenger Lane, Suite 101
Knoxville, TN 37922
tel: 1-865-966-6767
website: www.mpmediapro.com

Iconic Talent Agency
2431 Aloma Ave.
Winter Park, Fl 32792
tel: 1-800-598-2989 x 3
website: www.iconictalent.com

Imagine Event Management and Promotion
419 Lafayette Street, 4rd Floor
New York, NY 10003
tel: 1-212-517-6402
website: www.imagineep.com

Promosynthesis
300 Prarie Center Dr., Suite 225
Eden Prairie Center Dr., Suite 225
Eden Prairie, MN 55344
tel: 1-952-746-6980
website: www.promosynthesis.com

National Event Staffing
6021 Yonge Street, Suite 114
Toronto, ON M2M 3W2
tel: 1-866-565-9939
website: www.nationaleventstaffing.com

Market One Group
4144 N. Central Expressway, Suite 800
Dallas, TX 75204
tel: 1-214-826-9180/www.marketonegroup.com

Elite Productions, Inc.
5615 Richmond Ave., Suite 235
Houston, TX 77057
tel: 1-800-836-8556
fax: 1-713-914-0300
email: elitemail@geolite.com
website: www.geolite.com

Talent Pool Inc
2217-D Matthews Township Pkwy #310
Matthews, NC 28105
tel: 1-704-567-9911
fax: 1-866-839-7615
email: info@talentpoolinc.com
www.talentpoolinc.com

Chicago Freelance Spokesmodels
1960 Laura Lane, Suite 1
Chesterton, IN 46304
tel: 1-877-848-1379
email: spokesmodelsinc@cs.com
website: www.spokesmodels.com

This is an incredible resource, and Tracie Walker of Spokesmodels.com shared with me how the website can best benefit you. Go to the site and click under "National Tradeshow Independent Contracts," and make sure to join. After you have filled in your information, you will be emailed when there are jobs that are right for you and are in your area. It is very important to put your picture and resume on a disc and on your computer in order to immediately submit to those jobs. The opportunities include being a spokesmodel, a demonstrations model and a promotional model.

This information is great, pay scale greater still:

Spokesmodel.com Pay Scale:

$150: 2-3 hours/day
$200: 3-4 hours/day
$250: 5-6 hours/day
$300: 7-8 hours/day

*One last note: The owner prefers that you email questions vs. calling.

Pros and Cons of Promo Work:

PROS:
- These jobs are flexible.
- You are always learning about something new.
- You can make good money.
- On each job, you have the potential to learn about new jobs and new companies.
- Its okay to say "no" if you are doing something else or do not want to do the job; these companies know you are doing this to support your real passion.

CONS:
- Checks are usually sent at least 3-4 weeks after you work.
- You can be asked to work in the rain and snow.
- You are often working in high-trafficked areas with noise and air pollution.
- The work comes sporadically and you will need to have other jobs as well.

Conclusion

Some of these jobs may not initially pay your entire rent, but a combination of them surely will.

An Example of an "Odd Job" Month

1 dress on consignment:	$25
2 days personal assisting @15 an hour (8 hour days)	$240
3 days of babysitting @12 an hour, 4 hour shifts	$96
4 hours of a clinical trial @12 an hour	$48
5 days of a trade show @175 per day	$875
6 days of promotions @15 an hour (4 hour shifts)	$320
7 days of catering @15 an hour (5 hour shifts)	$525
8 hours of dog walking @10 an hour	$80
9 hours of focus groups (3 focus groups)	$225
10 hours of extra work (union) *	$250

TOTAL:
25 days of work = $2,783

Every month will vary; this is an example of what you could do.

* You will make less if you are non-union.

It is important to note that there is a tendency to work all the time and we need to seek balance, a difficult task in such an expensive city. Remember what Ernest Hemingway says: "Never mistake motion for action."

Some months I work constantly and make lots of cash and other months I focus exclusively on my art. Currently, I am working diligently to make this book a reality.

And One More Thing...

Have faith and know that if you are persistent at being on many companies' lists, the work will begin to tumble in, especially after you have done a great job on each assignment. Always email and call the companies to let them know what you have been doing and that you are available.

I know that these jobs can take up days and weeks of our lives, and that their main purpose is to help support our true goals. Yet, it is too easy to treat those days at work as unimportant, as lost time. I never want to lose one single day on this earth, and I hope that you, too, will find joy in these jobs, getting to know the people you work with, networking and learning about other companies, etc.

If, for example, you have a dog-walking job, you never know whom you will encounter at the dog park. In New York, it could be that casting director you have been sending your headshot to for months. Or maybe you are writing a book and the owner of that German shepherd just happens to be a publisher at Simon & Schuster.

One time, I went to make some copies of my resume and was looking rather unkempt. My mother had always told me to wear lipstick and look my best no matter what I was doing, but did I listen? There, standing beside me was a casting director I had contacted with my headshot. Let me tell you; I looked like a bag lady that day. I couldn't tell if she recognized me or not, but in my no-makeup, messy-hair state of being, she certainly wasn't going to run back to her office to find my picture in her file.

Life is short and each day is a gift. No matter what job you have to do to support your art, please try to enjoy the experience.

Final Note:

If you have the means to support yourself, go for it! After I have provided you with all the "odd jobs" I could think of, I wanted to add another point. If you have the means to jump into this career and pursue it without having to work, do it. Immerse yourself in the process. Throw away any guilt you may have as you are surrounded by the anxious chatter of struggling artists. If you are not desperate, thank God for that and embrace everything that has been given to you. Everyone has been given different gifts and if yours happens to be money, guard it, protect it and utilize it to the best of your ability to support your life and artistic goals.

WORK FORM

Some questions to ask yourself:

The work I do for money – can it help my career? Does it need to help my career? How much money do I need to make? What job would be best for me?

- ☐ Promotions
- ☐ coat checking
- ☐ teaching what I know
- ☐ mystery shopping
- ☐ research groups/clinical trials
- ☐ waiting tables/catering
- ☐ party dancer/DJ/MC
- ☐ "extra" work
- ☐ Production assistant-film, TV, theater
- ☐ administrative/office work
- ☐ other

"New York is an ugly city, a dirty city. Its climate is a scandal, its politics are used to frighten children, its traffic is madness, its competition is murderous. But there is one thing about it - once you have lived in New York and it has become your home, no place is good enough. All of everything is concentrated here...it goes all night! It is tireless and its air is charged with energy. I can work longer and harder without weariness in New York than anyplace else."

-John Steinbeck

FUN IS NOT A FOUR LETTER WORD

Whether you have been living in the city for a few years or have just arrived, you have probably figured out that New York is both very exciting and very stressful. Just to recap: the rent is downright scandalous, the real estate is the highest-priced for the least amount of space in almost the entire world, the noise pollution is rampant (from the man shouting obscenities, to the horn being blown in your ear), and it can be dangerous.

That being said, it is extremely important you find a happy, healthy way to do something just for fun to help relieve the stress. It doesn't matter what it is, as long as it makes you laugh and forget your troubles, even if only for an hour or two. Here are a few examples of the many pleasurable ways to spend time in this city: bowling on Fridays with a group of friends, a picnic in the park on a lazy Sunday afternoon (I know what you are thinking: "Who has time for a lazy afternoon?" I say, "Make time!") or enjoying an outdoor concert.

I had to learn the hard way that running around constantly could run a person down. Suffering from vertigo stunted my dance career, and it happened because I was running on empty and had no time to "re-create" myself. There are times when we give so much and do so much we need to refill our creative oxygen tank.

Most artists I know rehearse, create, sleep, try to eat, shower, try to eat some more, rehearse, create, go to a class, and then do the whole thing over again the next day. I do not

know many artists who have a day off. Their "day off" might mean they don't have a show on Monday but are still working a "survival" job or making phone calls looking for more work.

I have noticed that the simple act of "hanging out" is not very popular in New York. People go from work to a party at 7:00 to drinks with a friend at 9:30. Our agendas are filled with work and more work, and when we socialize; we fill up our evenings just as we do our workdays. There isn't much time to really connect with people when there is so much to do. If this city had a mantra, it would be: "Thou shall not relax!" I urge you to challenge this in your own way by creating easygoing evenings, mellow afternoons, and time to just be.

"Develop interest in life as you see it; in people, things, literature, music – the world is so rich, simply throbbing with rich treasures, beautiful souls and interesting people. Forget yourself."

- Henry Miller

The following are a few suggestions on how to have fun in the city without breaking the bank.

Fun, Cheap (or Free) Things to Do:

- Walk in Central Park
- Bike ride in Riverside Park or Central Park
- Go to the bookstore and read magazines
- Get comp tickets to see a friend's play or concert
- Usher a play or concert and see it for free
- Have a picnic in the park
- Throw a potluck dinner
- Rent a movie at Blockbuster (split the cost with a few friends)
- Take a free introductory class
- Find a team sport you like and start your own league

Club Free Time is a great magazine that lists at least twenty things to do for free or cheaply in New York City every day. You can see a play or concert; listen to an author read his/her latest book, catch a dance performance and more. A yearly subscription costs $13.95, well worth it for all the built-in savings. Check out www.clubfreetime.com for more information.

CHAPTER 4

SAVING MONEY

The Importance of Saving Money

Saving money does not come effortlessly to me, and living in New York City doesn't make it any easier. Everyday, we Manhattanites are surrounded by stores; racing to an audition, getting a bite to eat, strolling to Central Park or on our commute to the subway...stores, stores everywhere! Even during the current difficult economic climate (I hope that things are better by the time you are reading this book) we still see the new couch we "must have," that state-of-the-art camera we long to take on an African safari or a cool pair of suede boots. Currently I have a new computer calling my name, as this one freezes up with increasing frequency.

Therefore, the very nature of Manhattan neighborhoods makes it particularly difficult to save money. When I visit my family's home in Virginia, there is not a store for several miles, which allows for a "capitalistic-free" walk. Yes, people in the suburbs spend money (and hordes of it!) but they don't have dozens of stores competing for their attention (and dollar) every time they step out of the house.

It is difficult for most people to save in New York, but I think it is particularly challenging for artists as we have an insatiable desire to learn, to become excellent at what we do, and to keep current on new trends. Now, if you are exploring the possibility of the arts and you are part of the corporate world, I know you have those same desires. The difference is your company might pay for those "improving your skills" classes. We artists pay for all of our own classes, and while we

can use them as tax deductions, the money is still coming out of our own pockets.

Temptations of New York

New York has so much to offer, but for a newcomer it is easy to be distracted by all there is to do. If you weren't a penny pincher before you arrived and/or you are a financially generous person (to yourself and others), buyer beware! There is much to buy here in the way of dining, entertainment and general "stuff" (and that's on top of your rent, utilities, food and classes). I hope that my book will encourage you to make informed choices, and to sit down and earmark your money for your priorities, as it is oh-so-easy to be swayed by the lure of the Big Apple.

Saving Money: Actors

Actors are notorious for continuing education. As far as any actor that I know is concerned, until you are on television, in a Broadway show, in London on location shooting a film, or accepting an Oscar, you are in class (in fact, many people who are successful working actors are also still taking classes). I have taken classes the entire time I have lived in New York City, including programs at Lee Strasberg, Circle in the Square and The Royal Academy of Dramatic Arts in London. Unfortunately, taking the craft seriously has seriously drained my finances.

Most actors like to be in a scene study class, a voice class for speaking and/or singing, and some type of movement class (such as the Alexander Technique or yoga). A scene class could cost you $200 for a month of four. (In these classes, the motivated people work, so if you hang back you may only get to work once a month). Then you might have a voice class that could run between $200-400. The yoga alone will set you back at about $14 a class while the Alexander Technique workshops/courses typically add up to $150 a month.

Sample Month

Class:	Cost:
Dance	$600
Acting	$200
Voice	$200
Movement	$150
Total:	$1,150

Saving Money Tips: Actors

Now that you have seen how quickly things can add up, here is a way actors can cut costs. Most acting schools have work study programs in which you work a certain amount of hours in exchange for free or reduced-fee classes. Call the school(s) you are interested in to find out the specifics of their work/class exchange. At the School of Film and Television, if you work in their office for five hours a week, you will receive over $300 off a part-time class.

The following acting schools have work-study programs:

HB Studios
120 Bank Street
New York, NY 10014
tel: 1-212-675-2370
website: www.hbstudio.org

The School of Film and Television
39 W. 19th Street, 12th Floor
New York, NY 10011
tel: 1-212-645-0030
website: www.filmandtelevision.com/ www.sft.edu

T. Schreiber Studio
151 W. 26th Street, 7th Floor
New York, NY 10001
tel: 1-212-741-0209
website: www.t-s-s.org

Michael Howard Studios
152 W. 25th Street
New York, NY 10001
tel: 1-212-645-1525
website: www.michaelhowardstudios.com

Lee Strasberg Theatre Institute, Inc.
115 E. 15th Street
New York, NY 10003
tel: 1-212-533-5500
website: www.strasberg.com

Circle in the Square Theatre School
1633 Broadway @ 50th Street
New York, NY 10019
tel: 1-212-307-0388
e-mail: circleinthesquare@att.net
website: www.circlesquare.org

Saving Money: Dancers

As I have mentioned before, I came to New York as a dancer and there were many weeks where I was taking three classes per day at $10 a pop (now they are up to $15). Fortunately, there are work-study programs and other creative ways to reduce what you spend on classes. Below, find tips on significantly cutting down costs to do what you most love to do.

Saving Money Tips: Dancers

1. Ask if your dance studio has a work-study program. Each studio has a different policy, but the general principle involves you working once or twice a week (generally between 4-10 total hours) doing clerical work or cleaning, in exchange for free or greatly discounted classes. To take part in Steps on Broadway's program, for example, you need to interview and attend an orientation. In exchange for ten hours a week of work, (possibilities include cashiering at the front desk, café or boutique), you can take classes for $3 each instead of the usual $15.00. Some studios require a dance audition for the work-study program; others only do work exchanges with long-term students. Be sure to check out the work-study specifics at your favorite studio.

2. If you are consistently taking classes with one specific teacher and he/she gets to know you, you can do one of two things. If the teacher offers you free passes, then go ahead and take them! If you are not offered passes and are really strapped for cash, gently ask the teacher if you could help him/her out (running errands, trading a skill you have, etc.) in exchange for classes. The worst thing the teacher can do is say no, but you will not know unless you ask. Many teachers are open to helping a loyal student.

The following dance schools have work-study programs:

Steps on Broadway 2121 Broadway New York, NY 10023 tel: 1-212-874-2410 website: www.stepsnyc.com	Broadway Dance Center 221 W. 57th Street, 5th Floor New York, NY 10019 tel: 1-212-582-9304 website: www.bwydance.com
New Dance Group 254 W. 47th Street New York, NY 10036 tel: 1-212-719-2733 www.ndg.org	Dance New Amsterdam 280 Broadway, 2nd Floor New York, NY 10007 tel: 1-212-625-8369 www.dnadance.org
Alvin Ailey Dance Center 405 W.55th st. New York, NY 10019 tel: 1-212-405-9000 www.alvinailey.org	Peridance Center 132 Fourth Avenue, 2nd Floor New York, NY 10003 tel: 1-212-505-0886 www.peridance.com
Manhattan Motion 215 W. 76th Street, 4th Floor New York, NY 10023 tel: 1-212-724-1673 www.manhattanmotion.com	Merce Cunningham 55 Bethune Street New York, NY 10014 tel: 1-212-255-8240 www.merce.org

Saving Money: Visual Artists

The Art Students League of New York offers extremely affordable classes in drawing, painting, sculpture and more. Tuition is paid monthly, and classes range from once to several times a week.

The Art Students League of New York
215 W. 57th Street
New York, NY 10019
tel: 1-212-247-4510
website: www.theartstudentsleague.org
sample cost: "Drawing for Life" class meets 5 days a week for $175/month

Actors, Dancers, Singers and Musicians

The Lucy Moses School for Music and Dance has classes for students of all levels. If you are looking for inexpensive voice lessons, want to learn a new instrument or how to pirouette gracefully, this is the place to go.

The Lucy Moses School at Kaufman Cultural Center
129 W. 67th Street
New York, NY 10023
tel: 1-212-501-3360
website: www.ekcc.org

Saving Money Tips: Theatre

The place to go for discounted tickets to Broadway and Off-Broadway shows is the TKTS booth in Times Square (47th Street and Broadway). All tickets are for that day's or night's performance and are available for either half-price or three-quarter-price. Though the lines can be very long and the show of your choice might not be available that day, this is still a worthwhile endeavor for theatre lovers on a budget. For more information, go to www.tdf.org.

The Hit Show Club also offers theatre tickets at reduced prices, with coupons up to 50% off. For more information on where to find coupons or how to become a free member, call 1-212-581-4211 or visit www.hitshowclub.com.

For all you spontaneous theatergoers, Audience Extras sell unsold tickets to shows (of all kinds) on the actual performance date. For $115 a year, your membership allows you access to these prized $3 seats! Call 1-212-989-9550 or check out www.audienceextras.com for more info.

"Men who love humanity have all dreamed at least once during their lives of bringing all their fellow men together in a state of carefree happiness. And only the world of the theater ever really succeeds in doing this."
 -Jean Jacques Gautier

Saving Money: Shopping

New York is one of the fashion capitals of the world, which makes for excellent *"window"* shopping at some of the greatest designer shops in the world. Depending on our artistic path, fashion may inspire our art, inform us of a color trend or let us know what we need to wear at our next audition. However, we do not need to have expensive clothing in our closets in order to be stylish. I believe we should have special high quality items for important events, like an interview, presentation or wedding. Nevertheless, that does not, in my mind, rationalize spending $200 for a t-shirt because it sports a designer logo. Designers should pay *us* to advertise for them!

Most of my clothing is a combination of Wal-Mart, Macy's and Ann Taylor (sale items only), with a few Conway t-shirts and accessories thrown in. Some of my favorite moments are when people compliment me on how stylish my outfit is, and I get to tell them: "This watch was $10 at a hotel watch sale, this $50 skirt was over 50% off, this sweater was $25 on sale at Macy's," and the best part is "these leather-*esque* boots were $6.99 at Kmart." I love to see their expressions!

So please, I beg of you, do not be demoralized by the Gucci-wearing, Prada-carrying crowd. This can be an intimidating city, fashion-wise, but try to avoid temptation. With a little attention to detail, you too can look fabulous and continue to live economically. The following section will provide you with all the tools necessary to do so.

Thrift Shops

If you are looking for trendy, hip or retro clothing, check out the thrift shops listed below. Also, if you want to donate clothing and receive a tax deduction (make sure to get tax deduction forms from the organization), many will accept clothing and several will pick up your "treasures" directly from your home. Every thrift store is different. Some will only accept seasonal items, while others will not accept furniture, which is why it is important to always call ahead and see what they are currently accepting.

"The great thing about vintage is that it's neither in fashion nor out of fashion, so it doesn't come or go."

-Susan Orlean

Thrift Shop Contacts:

Vintage Thrift Shop
292 Third Avenue (btw 22nd & 23rd Streets)
tel: 1-212-871-0777

Housing Works Thrift Shop
157 E. 23rd Street (btw Lexington & 3rd Avenues)
tel: 1-212-529-5955

Cancer Care Thrift Shop
1480 Third Avenue (btw 83rd & 84th Streets)
tel: 1-212-879-9868

City Opera Thrift Shop
222 E. 23rd Street (btw 2nd & 3rd Avenues)
tel: 1-212-684-5344

Arthritis Thrift Shop
121 East 77th Street
tel: 1-212-772-8816

Note: There are many Goodwill and Salvation Army locations throughout the city. Check your phone book or search online at www.goodwill.org or www.salvationarmy.org for shopping and drop-off locations.

Discount Stores

We all need to shop; whether for food or clothing, it is a necessary part of life. As artists, we have many things competing for our money, so in making our essential purchases, discount stores are the way to go. The following list includes department store-like settings, such as Daffy's, and "anything goes" stores, like Jack's 99¢, that stock just about everything that you could imagine. Most of these stores have more than one location in Manhattan, so call for the one nearest you.

Discount Store Contacts

Daffy's 1311 Broadway (at W. 34th Street) tel: 1-212-736-4477	Conway 1333 Broadway (at W. 35th Street) tel: 1-212-967-4012
Jack's 99¢ 16 E. 40th Street (btw Madison & 5th Avenues) tel: 1-212-696-5767	Absolute Savings 230 5th Avenue (at 27th Street) tel: 1-212-545-1557
Century 21 22 Cortlandt Street (btw Broadway & Church Street) tel: 1-212-227-9092	Syms 400 Park Avenue (at E. 54th Street) tel: 1-212-317-8200
H&M 1328 Broadway (at W. 34th Street) tel: 1-646-473-1164	Old Navy 150 W. 34th Street (btw Broadway & 7th Avenue) tel: 1-212-594-0049
99¢ Creations 244 W. 23rd Street (btw 7th & 8th Avenues) tel: 1-212-627-2983	

"Good taste shouldn't have to cost anything extra."

-Micky Drexler

Sample Sales

These sales are held in warehouses and feature clothing from high-end designers at greatly reduced prices. To find out more about the sales and where to find them, check out the following list of websites.

Sample Sales Websites:

www.nysale.com
www.nymetro.com
www.citysearch.com
www.billiondollarbabes.com.

Consignment Stores

New York's consignment shops are great for two reasons: one, if you have to have the Gucci, Chanel or Prada purse/shoes, you can go to a consignment shop for a used one/pair. Instead of paying $700, maybe you will spend $200. (I am not recommending spending that much for a purse, but if you have a weakness for high fashion, at least try to purchase it secondhand.) Two, you can give them your high-end clothing (from your pre-economic days) in good condition and get some money back. With consignment stores, you are paid a percentage of the sale price *after* it is sold. (Be sure to call the store ahead of time to find out when they meet with new consigners.)

Consignment Store Contacts:

La Boutique
1045 Madison Avenue (btw 79th & 80th Streets)
tel: 1-212-517-8099

A Second Chance
1109 Lexington Avenue, 2nd Floor (btw 77th & 78th Streets)
tel: 1-212-744-6041

Encore, The Premier Consignment Shop
1132 Madison Avenue (btw 84th & 85th Streets)
tel: 1-212-879-2850

Designer Resale
324 E. 81st Street (btw 1st & 2nd Avenues)
tel: 1-212-734-3639

Fisch for the Hip
153 W. 18th Street (btw 6th & 7th Avenues)
tel: 1-212-633-9053

Michael's, The Consignment Shop for Women
1041 Madison Avenue (btw 79th & 80th Streets)
tel: 1-212-737-7273

"Style has nothing to do with money. Anybody can do it with money. The true art is to do it on a shoestring."

-Tom Hogan

Internet Spots for Selling

www.ebay.com - the famous website for "auctioning" off your rare and unique treasures

www.half.com - owned by ebay.com, this site lets you sell items within a wide variety of categories

www.amazon.com - log on here to sell everything, from books to kitchenware to electronics

Furniture Shopping

If you are in the market for new furniture, Ikea is the way to go. It offers a wide range and variety of home furnishings at great prices. They also provide a shuttle bus from Port Authority in Manhattan to their Elizabeth, New Jersey location and back.

IKEA – Elizabeth Center
1000 Center Dr.
Elizabeth, NJ 07201
tel: 1-908-289-4488
www.IKEA.com
hours: Monday-Saturday: 10 am – 9 pm, Sunday: 10 am – 6pm
shuttle bus info: 1-800-BUS-IKEA

Flea Markets

There are several pluses to flea markets. If you are an antiques lover, for instance, you can often find great deals. You can also always try to bargain and get a *really* great deal! Another nice aspect of flea markets: if you have things to sell, you can rent a table and peddle your wares.

Flea Market Contacts:

NoHo Market
714 Broadway and W. 4th Street
Open seven days a week
-clothing, jewelry, tapes, etc.

SoHo Antiques Fair
Grand Street & Broadway
tel: 1-212-682-6200
Saturdays & Sundays, 9:00 am – 5:00 pm
-antiques, crafts & miscellaneous products

The Garage
112 W. 25th Street (btw 6th & 7th Avenues)
tel: 1-212-647-0707
Saturdays and Sundays, 7:00 am – 5:00 pm
-indoor antiques market

Greenflea, Inc.
Columbus Ave. (btw 76th & 77th streets)
tel: 1-212-239-3025
www.greenfleamarkets.com
Sundays, 10:00am-6:00pm
-imports, crafts, antiques, books and fresh produce

Annex Antique Fair & Flea Market
6th Avenue (btw 24th-27th Streets)
tel: 1-212-243-5343
Saturdays and Sundays, from sunrise to sunset
-furniture, decorations, jewelry, clothing, artwork, etc.
$1.00 admission fee

Eighth Avenue Flea Market
312-318 Eighth Avenue
tel: 1-212-786-0161
fleamarketnyc@aol.com
Saturdays and Sundays, 8:00 am – 7:00 pm
-a large variety of products for sale

"Frugality – Make no expense but to do good to others or yourself; that is, waste nothing."

- Benjamin Franklin's Thirteen Virtues

Big Bad Infomercials

Most artists I know are night owls, and what does that mean? I hope that on good days it means that they are up late creating amazing pieces of artwork and dreaming. However, most artists I know have had plenty of insomnia-ridden nights without creative inspiration and end up watching a lot of late night TV-which leads to infomercials, very convincing advertisements that make you feel you can't possibly live without the item at hand.

Like many people living in New York City, I do not cook very much. I would like to cook more but my kitchen does not make it all that easy, due to the lack of counter space and the fact that it is in my living room! That being said, one of my resolutions this year was to cook more and save an enormous amount of money that normally goes to take-out. One night I was watching TV and an infomercial magically appeared showcasing a beautiful set of pots and pans (perfect for every wedding gift registry). Wanting to feel grown up and economically savvy, I spent $150 on pots and pans. The verdict: I still use only one pot for boiling pasta, which is about the extent of my culinary adventures.

So I warn you: beware of shopping choices not applicable to your current lifestyle. I sometimes think of donating the pots and pans to a charity, but I still have hopes that Prince Charming is coming and we will save our wedding guests money on presents (since they will not have to buy us pots and pans)!

Saving Money: Food

In New York City, it is excessively easy to spend a ton of money on food. Between having tiny kitchens that make take-out tempting and incredible restaurants everywhere you look, it is important to be conscious of where your food money goes. Since this book is about living well and not about deprivation, I am including restaurants that offer great meals at great prices.

> "Small, inexpensive restaurants are the home fires of New York City."
> -Maeve Brennan

Restaurants:

Dojo West
14 W. 4th Street (at Mercer Street)
tel: 1-212-505-8934
price range: $3.00-$10

Dojo is *the* place to go for a truly cheap and delicious meal. They have something for everyone, vegetarian food, Japanese noodles, burgers, breakfast food and more, all at unbeatable prices.

Dorian's
226 W. 79th Street (btw Broadway & Amsterdam)
tel: 1-212-595-4350
price range: lunch $7.95-$12.50, dinner $12.50-$20

Better Burger
178 Eighth Avenue (at 19th Street)
tel: 1-212-989-6688
price range: $3.20 - $12

Burger fix (veggie burgers too): go to Better Burger for a healthy, inexpensive meal. Try the air-baked "fries."

Say Cheese!
649 9th Avenue (at 46th Street)
tel: 1-212-265-8840
serves: grilled cheese, sandwiches, soups, vegetarian dishes
price range: $6 - $8

Island Burgers & Shakes
766 9th Avenue (at 50th Street)
tel: 1-212-307-7934
serves: burgers, chicken, vegetarian, salads…but no fries!
price range: $6 - $9.50

Grey Dog Café
33 Carmine Street
tel: 1-212-462-0041
serves: baked goods and coffee at a great price

Patio Dining
31 Second Avenue
tel: 1-212-462-0001
price range: $12-$22

Dallas BBQ
261 8th Avenue (at West 23rd Street)
tel: 1-212-462-0001
serves: barbeque chicken, steak, shrimp, cornbread
price range: $3.99 - $15.99* (*for "steak & shrimp")

Supermarkets:

Stiles Farmer's Market, Inc.
352 W. 52nd Street (btw 8th & 9th Avenues)
tel: 1-212-582-3088

Whole Foods
4 Union Square South
tel: 1-212-673-5388

Fairways
2127 Broadway (at W. 74th Street)
tel: 1-212-595-1888

Westerly Natural Market
911 Eighth Avenue (at W. 54th Street)
tel: 1-212-586-5262

Saving Money Tips: Food

- Buy the annual Time Out New York "Cheap Eats"
- Log on to www.citysearch.com and click on the "Cheap Eats"
- NYC delis have inexpensive breakfast, eggs&coffee under $3.

Saving Money: Beauty

Some of the world's top salons are in New York City, which is great for those who can afford to spend hundreds of dollars for a simple haircut. The rest of us need economical options for looking and feeling gorgeous.

Beauty Contacts:

Aveda is *the* destination for inexpensive haircuts, facials (facials $45 for 60 minutes) waxing and more. The "catch" is you are receiving these treatments from students. They are highly skilled and supervisors are present. At $18 a haircut, it does not get better. Call 3-4 weeks in advance.

Aveda
233 Spring Street (btw Varick Street & 6th Avenue)
tel: 1-212-807-1492
times: Tues. 1-5pm, Weds.-Sat. 9-5pm, no service Monday and Sunday

American Barber Institute (Beauty School)
252 W.29th st.
NY, NY 10001
tel: 1-212-290-2289
rates: Are you ready for this? Hair cut $3.99, Color $15.00

Model Cuts:

An exciting fact: Some of New York's most famous, upscale (read: expensive!) salons offer "model cuts" for a low cost, (and you don't have to be a model to participate).

Model Cuts Contacts:

Frederick Fekkai Beaute de Provence ($40)
15 E. 57th Street (at 5th Avenue)
tel: 1-212-753-9500

Louis Licari Salon ($30)
693 Fifth Avenue, 15th Floor (btw 54th & 55th Streets)
tel: 1-212-758-2090

Bumble and Bumble ($20)
415 W. 13th Street (at 9th Avenue)
tel: 1-866-7-BUMBLE
email: model@bumbleandbumble.com

John Sahag Salon ($25)
425 Madison Avenue (at 49th street9
tel: 1-212-750-7772

Vidal Sassoon Salon ($25)
730 Fifth Avenue, 2nd floor
tel: 1-212-535-9200

The Power of Slow & Steady

By Sanyika Calloway Boyce

Learning the importance of saving a little of everything you get is a powerful practice. Unfortunately, many people realize this too late. Time is a precious commodity that can't be bought, sold, or given away, and it's on your side. The span between your 18th & 30th birthday could mean hundreds of thousands of earned interest dollars in your pocket. The name of the game is compound interest. There are many complicated definitions for compound interest. However, a simple way of looking at compound interest would be to think of planting an acorn in the back yard when you are five years old. Time passes and you grow up, move away from home and return for a visit only to be surprised that the little acorn you planted and forgot about turned into a giant oak tree. Here's the secret to compound interest: It's not how much you have, but how soon you start saving (even a little) and the longer you commit to leaving the money alone. The longer it's there, the longer it has to work for you and the bigger it will grow.

The time value of money says; a dollar earned and saved today will be worth more tomorrow than a dollar earned and saved in the future. If I've confused you, allow me to explain to you what I mean: Consider two investors who are the same age, with the same annual income, and with similar investment goals. The only difference is that one starts investing earlier than the other.

Example: Investor One begins at age 25, contributes $2,000 each year for 10 years, and then stops adding money to the account. Investor Two begins investing at age 35 and invests $2,000 each year for 30 years. Assuming both earn a rate of return of 8% per year after expenses, can you predict who will have the most money at 65?

Investor Two is worth 22% less than Investor One. How is this possible? Time is the main ingredient. The compound interest had longer to work for Investor One. Just think if Investor One continued to save $2,000 per year. The total amount she would have accumulated with interest compounding would be $559,562 or $314,870 more than Investor Two accumulated!

Investment Summary

Investor	Years Invested	Total Invested	Worth of Investment at Age 65	Earnings
Age 25	10	$20,000	$314,870	$294,870
Age 35	30	$60,000	$244,692	$184,632

Source: vanguard.com

To order copies of Sanyika Calloway Boyce's books, schedule her to speak at your next event, or for general information, please contact:

Smart Concept Books
28 Vesey Street, Suite 2266
New York, NY 10007
(866) 432-2633
sanyika@sanyika.com, www.crackdacode.com

SUGAR DADDY, ANYONE?

One of the many jobs I've had was hosting for The Learning Annex (a wonderful seminar center where you can learn about everything from mosaic frame making to buying New York real estate). I was assisting at a seminar of Wayne Dyer's, a positive motivational speaker who has written many books, and before he finished his lecture, he challenged us to go outside and really take in our surroundings. He was saying that we often walk by stores and people without really paying attention to what we see.

Taking his advice, I walked out onto Central Park South to breathe in and absorb my environment. I focused on a person walking towards me and noticed he looked very familiar. A portly, seventy-something year old man with dyed brown hair, he resembled the musical director for a show I did in Brooklyn. When I got a closer look, I realized it wasn't him, but rather a stranger who was now staring back at me. He said hello, and I quickly explained that I had thought he was someone I knew. He said: "Well, okay, but how would you like to have dinner?" "No," I said, "I really need to get on my way." But he was very insistent and told me he was meeting a friend who was taking dance classes at the acclaimed Martha Graham Studio. This intrigued me, as I have danced all my life, so I decided free food at the Oak Bar at the Plaza Hotel -a place I don't frequently frequent- and interesting conversation would be great.

And an interesting conversation it was. It was such a worthwhile experience talking with this man and his dancer friend. It turned out she had inherited twelve million dollars from her father, and was struggling over whether or not to work. Our male companion was quite adamant that she should work, but I still felt there was no need unless she really wanted to. We discussed this man's theory that all actors and dancers in the city will end up as "chambermaids" (a very "old school" reference that reflected his age and millionaire status).

As the evening progressed, he began to focus his attention on me. He told me I shouldn't act or dance, but instead should work for him. After knowing me for two hours, he offered to pay for me to go back to school for Italian Translation. I do speak Italian, and when I finished studying, I could have become the president of his twenty-five million dollar hotel complex in Sardinia, Italy. Okay, the idea of going back to school to become expert in Italian is appealing, but being responsible for a twenty-five million dollar hotel? No thank you!

He told me that I would never make it as an actor and that I should take him up on his offer. I listened while enjoying my free dinner of crab cakes and lobster bisque, and found it interesting the way a stranger could have so many ideas for my life. He offered to show me his apartment, and though I know it sounds crazy, I accepted (he was in his seventies and weighed over 250 pounds, so I felt little fear...he couldn't catch me if he tried). His place was decorated with paneling, maps and ivory European-esque statues. It had a stellar view of Central Park

South. Upon entering his place, he began to divinely structure my life.

His plan:
1. He would pay for four years of Italian courses at NYU.
2. I would live in his gorgeous apartment for free.
3. I would have unlimited money for food.
4. After completing my degree, I would work for him in Italy.

The catch:
1. His neurotic cousin, who hated New York, would live with me and I would have to become her friend.
2. I would have to take care of his nine-year old son nine days a month (born to his x-wife, whose illness kept her from devoting all her energy to the KamaSutra...I'm telling you, I couldn't make this stuff up!).
3. I would not be allowed to pursue acting or any other art form, as it would surely never produce any money.

After the delicious dinner, captivating and disturbing conversation (that poor woman had to inherit twelve million and live with the "guilt") and an offer I just couldn't...accept (that's right, I didn't accept), he insisted on paying for my cab ride home (I lived less than ten blocks away!). I politely thanked him for the meal and he said, "I really enjoyed your company and I'm open to anything, even the possibility of being your sugar daddy." His pudgy face came toward me, and with that final comment, he placed a kiss on my cheek.

I honestly never thought I would hear the words, "I am open to being your sugar daddy" in my lifetime! On days like this, you just have to say, "I love New York!"

CHAPTER 5

KEEPING HEALTHY

KEEPING HEALTHY

When I watch shows like Entertainment Tonight and Access Hollywood, I am amazed at the stamina celebrities appear to have. It looks like they never rest, that their lives are one long version of "Trains, Planes and Automobiles" (a very funny Steve Martin movie). What's more, young stars seem to pop into the spotlight overnight (though if you read their bios, most have been acting, dancing or singing their entire lives).

There will always be those who quickly rise to superstardom, like the boy band 'N SYNC. I would love to see 'N SYNC singing and dancing for the next twenty years, but is that realistic (maybe for Justin Timberlake, but it looks like the band is now no more)? Keeping up the kind of stamina you need to have, to do what you love to do throughout your lifetime, requires staying healthy and strong along the way.

I learned the hard way the concept of the "artistic sprint" vs. the "artistic marathon." I wasn't eating enough to support the life I was leading (dance classes, acting classes, auditions, odd jobs, traveling) and it caught up with me. Unable to keep up with that hectic schedule, I knew I needed to take a break. It was during that resting period I realized if I was running myself into the ground, more than likely other artists were doing the same thing. Recognizing this and knowing that many performers don't have health insurance, I have written a chapter that encourages you to stay healthy and provides

resources for finding affordable health insurance and medical centers in New York City.

> "Health is something we do for ourselves, not something that is done to us; a journey rather than a destination; a dynamic, holistic and purposeful way of living."
>
> - Dr. Elliott Dacher

The Importance of Food, Sleep and Exercise

Food

Though the following bits of advice could easily fall under the heading of "common knowledge," while living the hectic artist's life, they are incredibly easy to forget. This city, like no other city, is filled with people eating on the run, skipping meals altogether and living on coffee and adrenaline.

I heard a Patti LaBelle interview in which she said she likes to travel with Prince and cook for him, because he never eats and lives on inspiration alone. This "meal plan" might work for Prince, but most of us need three well-balanced meals a day.

Food & Body Image

Growing up as a dancer, I was always (and still am) self-conscious about my weight. My breasts were bigger than anyone else's in class, and were accentuated by those tight-fitting leotards.

Though I started dancing as a little girl, I didn't dance in my late childhood and teenage years, a critical time for athletes and their developing muscles and coordination. Determined to make up for those lost years, I studied the basics with people learning them for the first time, mostly children and teenagers. They were all much skinnier than I was and it further accentuated how fat I felt (I never weighed more than 125).

Fortunately, though my feelings about being "overweight" were unhealthy, I never stopped eating or made myself throw up. Yet I never did eat enough. I would go to an audition, take three dance classes in one day and then go to an acting class, all on one big lunch.

This pattern did not keep my engine running well for long. You might think that a young adult's body is incapable of fatigue or running out of steam, but I am here to tell you that repeated under-eating causes serious burnout. Without proper nourishment, all those dreams you are working so hard to achieve will be lost, as you simply will not have the energy to keep going. Remember, in the performing arts, your body is your instrument.

Life Lessons

Here is a story to illustrate the importance of staying nutritionally sound. One day I had an important audition for a coveted summer internship. I thought I could run all over town before the audition without eating, show up, sing a song filled with effervescent personality (which I must say I have a ton of with or without food) and that would be that.

Maybe I had been able to do it in the past and maybe I could get away with it in the future, but not on this day. This was when I had not lived in the city long and did not know some important rules about auditioning for musical theater. I had practiced my song to a tape recording (at that time my voice teacher did not play the piano. Do your best to get a teacher that can teach you voice *and* play the piano...it will save you time and money) and felt really good about my song choice and how my voice sounded. Well, if you do singing auditions you know that piano players can play the same song in different tempos. The pianist played my piece much faster than I was used to, and I became very upset, noticeably upset. The casting director said, "Maybe you would like to try another song." I did, and that, too, was a flop. Then the tears began to flow. As I cried and cried, the casting director was truly kind and somehow I got the summer internship. I think she assumed I was crying because I really wanted the job and feared I had missed my chance, but I cried because I was so completely exhausted from not eating.

Sleep

If you knew me personally -and I feel that you will after I have shared my heart and knowledge with you in this book- then you would know that sleep is a very important part of my life. I try to get ten hours a night, much to the dismay of my grandparents and other conventional thinkers.

There are plenty of naysayers that are convinced I will never make anything of myself if I sleep this much. I will, however, continue to walk to the beat of my own drum, as I know what my body and soul require to be healthy and happy. Everyone has different sleep needs, so it is important to note and honor how much sleep *you* need to feel good and energized.

Career Longevity and the Need for Sleep

Networking can play a big role in an artist's effort to provide him/herself a viable living. Many actors, for example, will need to go to Broadway, Off-Broadway, Off-Off-Broadway, etc. to meet the actors, directors, casting directors and others who can help their career. Visual artists often are out "pounding the pavement" to show gallery owners their portfolios. And of all of this work to *get* work requires energy. Schmoozing and making contacts all day long can run any person ragged. With all of that effort, it is essential to look and feel as rested, healthy and vibrant as possible since you are your own commodity. If you are looking for career longevity, it is vital to view sleep as an integral part of your life and not as a frivolous luxury. Without it, your art will suffer, and more importantly, *you* will suffer.

Night Owl Syndrome
By Amy Harrell

The wee hours inspire
I just don't seem to tire
From 10 pm to 2
It seems there's nothing I can't do

It's amazing the potential
The creativity, pardon if I am referential
Edison up at 7 am, Franklin too
I have no idea, but it's something I am not going to do

For me it's the night
It just feels right
No need for natural light
The light in my mind is my might

So sing on those morning birds
Those worm eaters
Those with starched shirts

Catch 'em eat 'em up
I catch you later
In the evening...yup!

And who said:
"Early to bed, early to rise makes a man healthy
wealthy and wise"?
I don't know but I am determined to prove him wrong
So the night sounds ring and gong
And I am here to create all night long...

Exercise

Fortunately, most of you reading this book have grown up in a society that values and encourages physical exercise. You are bombarded with messages about health and fitness everywhere you look, and are therefore probably wondering why I am including such an obvious point in this book. Well, I believe that the importance of exercise simply cannot be overstated.

While in the process of writing this book, I have had to carve out the time for workouts. I take various dance classes and several walks in the park every week. Sometimes I catch myself so immersed in the creative process that I forget to take my own advice and neglect taking care of myself, something many artists are prone to doing. When I break the pattern by going out for a walk or eating a meal, I always feel so much better and more creatively inspired.

Though exercise is important, the way you do it isn't. You certainly don't have to be chained to a gym and those steep monthly fees*. It's up to you to find what works for your needs and your body. Maybe you like long walks in Central Park in the early hours when the sun has just risen, or ice- skating at Chelsea Piers (on the West Side Highway at 23rd st.). If you love rollerblading, try "commuting" that way (a good money-saver), or if you are a homebody, pop in an aerobics video (this requires actually working out, not just watching others do it on TV!).

I like variety in my exercise routine, with dance being at the top of my list. The most important thing is that you find what you like and do it on a consistent basis. It will help you look and feel great.

*An amazing, affordable alternative to the usual gym membership is the American Health and Fitness Alliance coupon book. For only $65, you get over four hundred passes to various gyms around the city, as well as personal training sessions and discounts at different fitness-related stores. For more information, visit www.health-fitness.org or call 1-212-808-0765.

Alcohol, Drugs and Smoking

You have probably heard a million times (from TV ads or your parents) that alcohol and drugs can harm your body, mind and spirit. When you are young and full of energy you might not feel the impact of these substances on your body, but in time you will and more than likely, it will affect not only you but your career, as well.

I find that New York is already exhausting (as well as exhilarating) and using these substances can cause further exhaustion. An excessive lifestyle can have negative effects on your personal and professional life. Have you seen how many celebrities have been in rehab?

Most importantly, I love being present in every moment. I want to be fully conscious and have access to all the gifts life has to offer. And that, my reader and friend, is what I wish for you.

Megan Franzen, Certified Holistic Health Counselor and Wellness Coach

Are you working with your body or against it? Do you suffer from low energy, indigestion, bloating, or experience stress and anxiety around food? Have you been trying to lose "those last few pounds" for years without success? There are so many books and programs for weight loss - and they all say something completely different! Are you confused? It's time to consult a professional. I work with actors, singers and dancers who need their bodies to be working well and looking great in order to get the gig. I also work with artists who do the "Superman" thing...corporate by day, creative by night. My programs help you pull it all together and create a fantastic life. After working with me, my clients look forward to getting out of bed every morning. Isn't that what you really need? And that's just the first benefit!

I work with people one-on-one and in small groups. I offer workshops, topic discussions, cooking classes and natural market tours. Are you ready to start feeling fantastic? Check out my website, www.angelsonghealth.com and contact me for an initial consultation. I am 100% committed to working with you to accomplish your health goals. But don't be surprised if we unleash some brilliance in your life along the way.

Megan Franzen at Angel Song Health
e-mail:megan@angelsonghealth.com

HEALTH INSURANCE

It's hard to believe that many young, well-educated and motivated artists do not have health insurance, but it's true. I meet artists every day who work odd jobs, take dance classes and lead very active, adventurous lives yet have no medical coverage. Between the risk for injury (in a dancer's life, particularly) and the very real possibility of getting physically rundown, it is dangerous not to be insured. Artists spend so much energy and focus on making money to pay bills and increase their artistic skills that health care often takes the back burner. What's more, the high cost of personal health insurance, when not covered by a corporation, can run an off-putting and staggering $400-$500 a month!

My goal is for you to make health insurance a priority. In this chapter, I will provide resources to educate you on available plans for artists and the self-employed. Remember, you may be a cautious and healthy person, but accidents happen. What would you do if you were in a terrible accident and didn't have the money to go to the hospital? While the following insurance plans are for coverage in New York, if you're a member of a union, you will be covered wherever you go. However, I know many of you aren't covered and I have provided resources below to help you with finding economic health insurance as well as clinics that will work with uninsured people. For specific details of all the plans, be sure to contact the organizations directly.

Health Plans for Artists

Working Today is a Freelancers' Union that provides health coverage to those working twenty plus hours a week in a variety of fields, including Arts & Entertainment. The plan, for $175-$270 per month, includes access to over 20,000 doctors and top New York City hospitals.

55 Washington Street, Suite 557
Brooklyn, NY 11201
tel: 1-718-222-1099, ext. 103
email: membership@workingtoday.org
website: www.workingtoday.org or www.freelancersunion.org

Fractured Atlas provides benefits and resources of all kinds to artists of all kinds. The yearly membership ($75), in addition to offering healthcare plans at incredibly low rates (starting as low as $60 per month), gives you a community of support for artistic projects, grant applications, job opportunities and more.

248 W.35 st., suite 1202
New York, NY 10001
tel: 1-917-606-0857
email: support@fracturedatlas.org
website: www.fracturedatlas.org

Artists' Health Insurance Resource Center, through the Actors' Fund of America, provides a database of insurance plans for artists, as well as those who are self-employed or earn a low income.

729 Seventh Avenue, 10th Floor
New York, NY 10019
tel: 1-212-221-7300
email: AHIRC@actorsfund.org
website: www.actorsfund.org

Artists' Unions

Each union has its own requirement for health insurance eligibility. You will have to earn a certain amount of income or work a particular length of time to qualify for benefits. Union rules change frequently.

Screen Actors' Guild
360 Madison Avenue, 12th Floor
New York, NY 10017
tel: 1-212-944-1030
email: screenactor@sag.org
website: www.sag.org

American Federation of Television and Radio Artists
Health & Retirement Funds
261 Madison Avenue
New York, NY 10016
tel: 1-212-499-4800
email: webpage@aftrahr.com
website: www.aftrahr.com

Actors' Equity Association
165 W. 46th Street
New York, NY 10036
tel: 1-212-869-9380
fax: 1-212-398-2826
email: info@actorsequity.org
website: www.equityleague.org

American Federation of Musicians
1501 Broadway, Suite 600
New York, NY 10036
tel: 1-212-869-1330
website: www.afm.org

The Dramatists Guild of America, Inc.
1501 Broadway, Suite 701
New York, NY 10036
tel: 1-212-398-9366
website: www.dramaguild.com

The American Society of Composers, Authors and Publishers
One Lincoln Plaza
New York, NY 10023
tel: 1-212-621-6000
email: info@ascap.com
website: www.ascap.com

The Entertainment Industry Group Insurance Trust
845 Third Avenue, 20th Floor
New York, NY 10022
tel: 1-800-886-7504
email: teigit@teigit.com
website: www.teigit.com

Health Centers

Miller Health Care Institute for Performing Artists is the largest national healthcare facility established exclusively for the needs of performing artists and offers a wide range of alternative and conventional medical treatments. The Institute accepts most major insurance plans but also provides a sliding scale for uninsured patients.

355 West 52nd Street, 7th floor
New York, NY 10019
tel: 1-646-778-5550
email: info@millerinstitute.org
website: www.millerinstitute.org

D•O•C•S is a prestigious clinic that treats both the insured and uninsured. Those without coverage will be charged reasonable fees for checkups and treatments (starting at $100). The location below is one of three in Manhattan.

55 East 34th Street
New York, NY 10016
tel: 1-212-252-6000
tel: 1-800-673-3627

Physician Volunteers for the Arts provides free medical care for artists without insurance. The center is meant to be a one-time resource to help those in need, and provides referrals to specialists in every field. Hours are limited to Tuesday from 9:00 am – 12:00 pm and Thursday from 1:00 – 5:00 pm.

The Aurora Center
475 W. 57th Street, 2nd Floor
New York, NY 10019
tel: 212-489-2020, ext. 140

The New York City Free Clinic offers free medical services for those without insurance. Appointments are only available for Saturday mornings and often have long waiting lists; walk-ins are not accepted.

Sidney Hillman Health Center
16 E. 16th Street, 3rd Floor
New York, NY 10003
tel: 1-212-924-7744

Low Income Plans

MetroPlus Family Health Plan offers cost-free medical coverage for individuals and families. To be eligible for an individual plan, you cannot make more than $9,310 a year.
tel: 1-800-475-METRO
website: www.metroplus.org

Healthy NY provides affordable health care plans for those that are working and uninsured. For an individual plan, your yearly income cannot exceed $23,275. Monthly insurance plan rates start at approximately $140.
tel: 1-866-HEALTHY/1-866-432-5849
website: www.healthyny.com

Broadway Cares
165 West 46th street, #1300
tel: 1-212-840-0770
fax: 1-212-840-0551
www.broadwaycares.org

"The happiness of the body consists in the possession of health; that of the mind, in being sensible of that blessing."
 -Anonymous

The Joy of Giving

When people hear the word "charity," they immediately think of giving money to someone or some organization. Most artists are not living with extra money. However, some of my greatest experiences in New York City have involved giving my time to charities. Doing for others has allowed me to take a much-needed break from myself and help who are less fortunate.

I had the wonderful opportunity of helping with a program called the "Lamb's Kids" (unfortunately, it has since been discontinued), a free after-school program for children whose parents were working multiple jobs trying to make ends meet. There, they were greeted by young adult volunteers who would give them a hearty snack, read and talk with them, and help with homework. In addition to those things, I was able to contribute my love of dance by choreographing their Christmas play. Teaching those young children, who otherwise wouldn't have been able to afford dance classes, was one of the most rewarding things I have ever done. They did such a beautiful job dancing, giving it everything they had, and all with little to no training. By sharing what I had learned, I ended up receiving so much enjoyment and love from the experience.

"God has given us two hands, one to receive with and the other to give with."

-Billy Graham

St. Paul's Christmas Dinner at Holy Cross Church

One Christmas, I helped out at the St. Paul's Christmas Dinner Party, where they feed several hundred homeless people every year. While serving dinner and handing out gifts, I experienced an unexpected, beautiful moment. I met an elderly African-American homeless man who was present in mind and spirit. After we talked for a little while during dinner, he opened his present (assigned randomly), which happened to be a pair of warm gloves, and his eyes filled with tears. "This year my gloves were stolen," he explained, "and I really needed these."

When we encounter those who are grateful for a pair of gloves, we are reminded to be thankful for the bounty that we have. All of my friends, even if they refer to themselves as "starving," have enough to eat and plenty of things. More than likely, if you have bought this book you have a place to sleep tonight, even if it is on an air mattress or a friend's couch.

Not only was that man blessed that evening at the Holy Cross Church, I, too, was blessed. It so happened that I ran into a woman I knew from church who mentioned that she was hiring people to work trade shows at the Jacob Javits Center. She asked me if I would like to work for her, and eight years later, I still do! These trade shows have been a great source of extra income. So in one night, while giving my time and encouragement, I too received a helping hand. (Note: Author

cannot guarantee work will come your way at every charity event, but hey, you never know!)

There are many wonderful charities in New York City, and I recommend finding one that supports an issue close to your heart. I especially love Habitat for Humanity, an organization that builds houses for families living on very little income. I have yet to work on a building team, but I know that one day I will; in the meantime I help out financially. Remember, even if you have only five dollars to give, that will buy a box of nails. Think of how many nails are needed to build a house!

Hope for New York tel: 1-212-808-4460 www.hfny.org service: trains & connects volunteers with organizations around the city	Habitat for Humanity tel: 1-718-246-5656 www.habitatnyc.org service: builds & refurbishes homes for people in need
Midtown Pregnancy Support Center tel: 1-212-689-1705 www.mpsc.org service: provides emotional & practical resources for pregnant women	The Bowery Mission tel: 1-800-BOWERY-1 www.bowery.org service: provides food, shelter, clothing & job training to the homeless
God's Love We Deliver tel: 1-212-294-8100 www.godslovewedeliver.org service: delivers healthy meals to those with HIV/AIDS and other illnesses	City Harvest tel: 1-917-351-8700 www.cityharvest.org service: provides food to the hungry

THE IMPORTANCE OF FRIENDS AND FAMILY

We come to New York because we want to be excellent at what we do, and to learn from the best people in whatever art form we have chosen. If we weren't driven, we would have stayed in our hometowns.

So now you are here. Most of you will quickly learn the many challenges of living in New York City: finding an apartment, getting a "survival" job, navigating your way through classes, internships and artistic job interviews/auditions. All of this can lead you down a twisted road before finding what is best for you.

Much of your time will be focused on getting better at what you do; meeting the people, you need to meet and generally learning how to "make it." Your well-meaning friends and family may think you are being selfish. After all, you left home; you are pursuing something for yourself, and may not be able to go home for holiday visits.

I understand firsthand the importance of an artistic vision, yet it is important to not lose sight of the big picture and neglect every other aspect of our lives. I encourage you to not pursue your art to the detriment of your health and/or your relationship with your family and friends. If you neglect all of these things in pursuit of excellence but are running on empty, will any future success have been worth it?

"Call it a clan, call it a network, call it a tribe, call it a family. Whatever you call it, whoever you are, you need one."

-Jane Howard

The "Gypsy" Lifestyle

Many artists live like gypsies and go where the work is; as such, it can be challenging to establish long-lasting friendships. In the past, I have done shows in New York, Ohio, Vermont and New Hampshire. Over a three-year period, I was away more than I was in New York, and was always working with new people. There were times I would call my mother and sob because of the lack of true friends. The love of dancing is what kept me going. The conflict lies in finding a balance. You want good relationships and yet you still want to perform. When artists do have the chance to work in the city in which they live, it is a blessing.

Some of you may be thinking, "How do I have time for friendships? I work so hard, I'm so tired, I have so much to do." I have had all these same thoughts. Yet when we neglect our body, mind and spirit; we leave ourselves open for "burnout." Friendships recharge our batteries. Remember, the artistic journey is a marathon, not a sprint.

Pleasing Friends & Family

Some of you may have parents who have led a fulfilling artistic lifestyle and are wholeheartedly supportive of your choices. Many parents, however, feel the decision to pursue art will lead to certain poverty (go to saving money chapter). As you begin on this journey, there is a great possibility you won't be pleasing your parents. Many well-meaning parents think you should

be working a forty-hour workweek, buying a nice car and a house in the suburbs, even if it means sacrificing your gifts and happiness.

Artists are inspiring; we are leaders and illuminators. We have talents and skills that are worth more to us than a coordinated living room. We do not always have something to "show" for our passion and efforts, unless there is an exhibit, show or published work.

My family couldn't come to all of my shows and couldn't see my progress. It is still hard for them to understand why I would put my heart into something that pays very little. The projects I have worked on have provided me with more than money–invaluable experience, confidence, the ability to work with others, perseverance, determination and courage. Yet my success is judged by the amount of money I make.

I believe in pursuing whatever it is you most love to do. Having tried so many times to get through to my family, I have we think differently. Do not waste one more minute trying to convince them. Thank them for their concern, take good care of yourself and go forward.

INTERVIEW: JESSICA LYNCH
Miss New York 2003

Amy: Thank you for taking time to speak with me. I know you have much to do to prepare for the Miss America Pageant. Why did you start doing pageants?

Jessica: I did a pageant in high school in Memphis, Tennessee and I won. After winning, I saw an article in the paper that gave the number to call for an application for Miss Memphis and thought about it but didn't follow through. As fate would have it, the next day one arrived in the mail. At the high school pageant there had been a talent scout and he sent me one. I entered the pageant and got 2nd runner up. I later moved to VA, entered a pageant there, and became 1st runner up. Upon graduating college in three years, I was anxious to go to New York and pursue theater and dance. I really believed that I left the pageant world behind, but when Sept. 11th happened I felt I needed to get out there and help people. My platform is mental illness.

Amy: What interested you in mental illness? Why did you choose that to be your platform?

Jessica: I have had mental illness since I was a very little girl. [Trust me if you met her there would be no indicators of this, she is a bright and beautiful young woman.] I know the firsthand stigmas associated with mental illness, as well as the difficulties in getting health insurance when you have a pre-

existing condition. It appears to me health insurance is only for the healthy. Pageants have been a way for me to showcase my dance talent; however, I see pageants more for how I can give a voice of hope for others who struggle with mental illness. I talk with legislators about the importance of health insurance covering the costs of medicine and therapy.

Amy: Thank you for sharing your own struggles. I know that you will be a source of encouragement to others, knowing you have accomplished so much even with this problem. I am encouraged to meet someone who has tackled head on the problems that have faced her. Living in New York City is not easy, where do you find your support?

Jessica: My family has always made it clear to me that they believe in my talent and they are very supportive in so many ways, but like many parents they don't quite comprehend how difficult it is to "make it" and stay making it in New York City.

When I first got to New York City, before I became Miss New York City 2003 [She went on to become Miss New York 2003 and went to the Miss America Pageant, but unfortunately did not become Miss America] I auditioned for the Radio City Christmas Show and made it. It was so great to come to the city and get a great job right away, but at the same time, it gave me a false sense of security that I would always be working and would always be making that kind of money. My parents would like me to have that kind of success all of the time. I have a boyfriend who is starring on Broadway. He is a

successful artist and knows what is really going on behind the scenes and what it takes to be there and stay there. He shows me how to be my own person and to not be concerned about what other people think. I also have two great roommates and I have found some friends outside of show business who are supportive.

I think it is really important to have people who are in your life that really like themselves and who are really happy with what they are doing in their life.

Amy: Jessica, Thank you once again for sharing your very important and inspiring story with me. I wish you all the best.

"Ignore nay-sayers and eventually they will grow silent. Refuse to think otherwise and eventually fate will see it your way. Dwell in the reality of your vision and eventually the world will see the result of a made-up mind. Believe in your story and eventually it will be told."

- Anonymous

Hotlines

I hope this chapter helps you live a healthy, happy life, but if you are ever in dire straits, do not hesitate to reach out for help from these hotlines.

AIDS Hotline
tel: 1-212-447-8200/1-800-243-7692

Alcohol Help Hotline
tel: 1-800-ALCALLS/1-888-425-2666

Drugs Anonymous
tel: 1-212-874-0700

Domestic Violence Hotline
tel: 1-800-621-HOPE

Sexual Assaults Hotline
tel: 1-212-267-RAPE/1-800-656-HOPE

Suicide Hotline
tel: 1-212-532-2400/1-800-SUICIDE

"The first wealth is health."

-Ralph Waldo Emerson

CHAPTER 6

ECONOMIC TRAVEL FOR ARTISTS

ECONOMIC TRAVEL

Whether you are searching for that next great photograph, researching information for a new story, auditioning for a traveling show, or simply need to get away to clear out the cobwebs and start anew, traveling is a vital and important part of an artist's life.

This chapter will highlight some of the great things I have learned while traveling. I have discovered excellent accommodations made to suit your budget, creative ways to make the trip more pleasurable, and tips to make packing a cinch. I've also added a few of my own stories to let you know that these aren't just ideas; people really do travel this way.

Where would you go if you weren't worried about how much it cost? _____ (fill in the blank with your dream destination). I am happily confident that this chapter will help you make your travel dreams a reality. I know many of you nomadic spirits have already been traveling, so hopefully you can keep that "wanderlust" spark alive with the tips herein.

A word of warning: the "Travel Chapter" is for those of you willing to forgo some luxury items (no, youth hostels are not the place to go to stock up on fancy soaps and shampoos). This is not a chapter on how to travel like the rich and famous. Instead, the following section will provide you with the tools you need to see the world on a serious budget.

My Travel Background

When people ask me if I have traveled much, I often fumble for words in an attempt at humility. While my "inner travel child" is smiling and happy and longs to scream out "oh yes, and let me tell you where!" my modest upbringing whispers: "be careful what you say as jealousy may ensue." Well, I hope that you are enjoying this book so far and I hope that you find it both practical and encouraging. And hopefully after reading the next paragraph you will continue with me.

Yes, I have traveled a lot. A LOT! A TON! A HUMONGOUS AMOUNT! A LIFETIME'S WORTH! I have been to Italy, Spain, France, England, Germany, Austria, Switzerland, New Zealand and many states throughout the United States.

Here's the thing: in all of my traveling, I have rarely stayed in hotels. Instead, I lodged in youth hostels, with friends, and in rented rooms, eaten grocery store food and created personal picnics in the park. I hope that my experiences will inspire you to travel more frequently and economically.

Benefits of Travel

For an artist, the benefits of travel are plentiful. Much of our time is already spent in imagination, perhaps envisioning painting on a deserted island, playing music at MardiGras or performing socio-dramas for children nationwide. When we fulfill our imaginations by actually experiencing these adventures, we renew our hope and sense of purpose, and inspire others to do the same. In turn, our confidence as artists continues to grow.

I had always dreamed of taking a painting vacation, a fantasy that was realized on the island of Sardinia. The peace I felt while painting on the beach for those five days is indescribable, capped by the incredible liberation of honing my craft topless! There really isn't anything like doing what you love to do, half-naked.

For a week, I did nothing but nurture myself artistically. I dropped all thoughts of "success" (such as: will this piece make me rich and famous?) and created freely, without pressure or anxiety. I quieted the voices of the world by going to a place where I could do what I felt I was meant to do – create. Giving myself permission to create something that I wanted to create even if I wasn't sure that the world needed it and it was liberating.

I do not want to discourage those who wish to create great success, but I do want to encourage artists to always take time to nurture the part that longs to create solely for the sake of creating.

Changing locations whether it's through a quick train ride, or a ten-hour plane trip, allows us to step back from our current circumstances and gain a new, expanded perspective. It may show us that we are on the right path or it may illuminate the areas that need to be changed or modified.

Artists & Travel – A Necessary "Luxury"

Artists need travel because inspiration comes from exploring the world, changing the routine and embracing the wanderlust in so many of our hearts. Somehow, away from our tiny apartments, numerous odd jobs and the hustle and bustle, we rediscover that inner core and know we must give ourselves time and permission to create.

No one else is going to give us that permission. Rather, they will give us "permission" to take a job that we don't like, just so we have a "real job." Trust me, in all of my experiences as an artist, it is definitely work and it is definitely real. I would like to see those office workers try a three-hour dance rehearsal; then we would see who's really working. Those capitalistic bellies would be panting. I can see them now.

In New York, there is an intense emphasis on work, success, money and moving at lightning speed. I have found that when we are on the artistic journey, we will experience times of rapid growth (maybe we attend a seminar and a light bulb goes off). Other times, we need to let things germinate under our gentle care and not take action.

Sometimes the city can appear to scream, "It's not happening fast enough! You are not getting any younger! You're

not competitive enough!" This is when a short vacation, even for two days, can help you access your level of progress and find acceptance for where you are on your path.

Traveling for Work

Travel is an important component to the freelance artist's life, whether you are touring the country promoting your book, on location for a no budget film or taking pictures in a small southern town, unless a company or sponsorship is covering you, the responsibility will lie with you to pay for your transportation and lodging.

If we are going to make money with our art, we need to shop around for the best prices. I know that this may seem obvious, but my purpose here is to illuminate all the means to make travel more economic. (I do not like the word "cheap" because I am not suggesting that you stay in places that are seedy and house those that are prospering in an ancient moneymaking business, i.e., prostitution. It would be terrible to risk your well being just to save a buck or two.)

"Dreams are almost always taller than you are...that way you have to reach to make them come true.
 - Anonymous

Packing for Work Travel

If you can, keep a suitcase fully stocked with basics so that you are prepared to leave for a work assignment at a moment's notice. Key packing "ingredients" might include socks, underwear, toiletries, a book, a journal, makeup, jeans, t-shirts and pajamas.

When traveling for a job, pack what you need to look your best and work your best. Take that special travel vest for your camera or those indispensable pair of dance shoes. Never assume that you will be able to find the equipment you need in the town or city in which you are traveling (I speak from personal experience). If your trip is extended, you can always buy an extra t-shirt or pair of underwear. By focusing on essentials and bringing fewer extraneous items, you will find more time to concentrate on your work and travel experience.

Packing Tips for Your Journey

➢ Bring all the artistic equipment you could possibly need; this is not an area in which to "skimp" as you consider what to pack.

➢ Invest in some wrinkle-resistant clothing. This will not be cheap, but if you are auditioning/interviewing in a new place, you will want to look your best.

➢ Sometimes less is not more when it comes to packing for an artistic trip. The times I have packed lightly, I have often regretted it, as I did not end up having essential items.

Flights

Once you have decided on your destination, there are many ways to get there. You could walk, take a bus or train, rent a car or fly. Though walking is the most economical choice, it significantly limits your travel options (that photography adventure in the Galapagos Islands, for instance). Flying is a popular way to get to those faraway places, but flight costs can be expensive. Check out a few Internet sites I have found particularly helpful in securing a bargain fare.

> www.hotwire.com is one of my favorites. You enter where you want to go and when and it will pull up the lowest prices that it can find. If you need a multiple city ticket or if you need to change your ticket, it does not allow this flexibility. Try www.expedia.com instead.

> www.statravel.com is a great one-stop-shopping place for all of your travel needs, especially if you fall in the 18-26 year old age group. The site is set up to help with inexpensive flights, tours, budget hotels, hostels, language programs, travel insurance, ID cards, passports and visas. STA Travel has many New York locations; their most centralized office is at 205 E. 42nd Street (1-212-822-2700).

- www.kayak.com

- www.priceline.com

- www.cheaptrips.com

- www.mobissimo.com

- www.lowestfare.com

- www.sidestep.com

Travel Tip: JFK is a New York airport that is frequently used for international travel. For an economically sound way to get there, take the A train (heading towards Far Rockaway, not the A train to Lefferts Boulevard) to Howard Beach station, and from there, take the AirTrain (cost:$5.00 + subway cost) to the airport. The AirTrain is also available via the E, J and Z lines at Sutphin Blvd-Archer Ave (Jamaica Station). This is a cost-effective alternative to a bus from Port Authority ($12-15) or a cab ($45 plus tolls and tip).

Accommodations

Okay, so you have found an amazing deal on a flight and are raring to go...but where will you stay?

When you think of lodgings, try to keep an open mind to the many possible types of accommodations. (If you have a Let's Go book and are traveling internationally, many of these categories will be represented. However, if for any reason you cannot find a place to stay, stop by the local tourism office and ask for creative suggestions.) I have stayed in a monastery in San Gimignano, in my travel agent's house* in Spain and in a rented room in a private home in Austria. Staying with warm and generous friends can be another fun way to save costs. In addition, I have had great experiences staying in university dorms. During the summertime, there are many available rooms, an option I enjoyed as a teen with my church choir group.

*I had bought a flight from Seville, Spain to Italy, but when I went to board, the gate attendant said the ticket was not there. She apologized but told me to talk to my travel agent, who was deeply embarrassed when she realized she had taken the ticket and not the receipt during my transaction. She invited me to stay in her home for the night, an offer I gratefully accepted, and I proceeded to have a lovely visit with her non-English speaking family. We didn't understand a word the other said, but found other ways (including sign language) to communicate.

So when considering your options, explore the following possibilities to find the best one for you and your dollar.

- Hotels
- Hostels
- Friends & Relatives
- University dormitories
- Private home-stays
- Camping

Hotels

If saving money is your goal, I don't recommend staying in a hotel. Most "cheap" hotels in America now run between $60-80 a night (outside of New York City). As for European hotels, I warn you that they are often old, have less-than-modern facilities and smell, well, un-fresh. I have stayed in one or two truly nice hotels, but they did cost a pretty penny.

Here are a few points in favor of hotels: If you are traveling for many weeks, it's a good idea to book in advance a few hotels where you can take a really good shower, have some privacy and maybe even relax and watch TV. You might be wondering why anyone would go to Europe and watch TV? Well, if you are there long enough, you will need to take an occasional break from sightseeing. Also, if you are learning the local language, television can be a very useful tool.

I knew that I was really grasping Italian when I could understand the rapid-speaking broadcasters on the nightly news.

It's also a nice luxury to have a large bed, where you can spread out the contents of your luggage and decide what can stay and what can go. You might want to ship some things home or possibly even donate extra items to maids in the hotel or to a nearby charity or orphanage. This can be a helpful process after traveling for months, when the thought of schlepping all those clothes home seems less than desirable.

But in the interest of saving money and having the most interesting, adventurous times, I recommend hostels, university dormitories, camping (seasonally, of course), residential homes, or friends and relatives.

Look up the following websites to find information on hotel discounts and cheaper rates:

www.hotels.com
www.hotelsdiscount.com
www.quikbook.com
www.tripadvisor.com

Hostels

Hostels vary in shape, size, activities, price and ambiance. Some are quiet and perfect for resting after a long day of sightseeing. Others, at nighttime, are bustling with guitar players, games and beer drinking. Some will have many rooms, others very few. One may have a shared room for four, a luxury compared to the twelve-per-room alternatives. If you are lucky, you will find a hostel that is close to the center of town or near public transportation; but there will be times that you will have to walk quite a ways. That is why it is so important to pack light and ship souvenirs and packages home.

Some hostels will provide travel information and even someone to act as a local guide. In Zurich, Switzerland, one hostel had an office where you could buy tickets to buses, boats, shows and museums. They also had nice little perks like vending machines and a pool table. I remember thinking that was really the "Flagship Hostel", one that other hostels should try to emulate.

Overall, my favorite hostel is a Pink Hostel, located in a small town on the French Riviera (it is near Nice). For twelve dollars, I got a bed, bread with hot chocolate (also known as "breakfast" to many Europeans) and a gorgeous view of the Mediterranean bouncing off the craggy rocks. Everyday, I would walk through the hilly neighborhood to a small, enclosed private beach. Paradise for twelve bucks; it simply does not get any better than that.

Hostels & Safety

Most of the time, hostels are a safe and dry place to sleep, which might be all you are hoping to find. Although I have mostly felt safe and secure, I still highly recommend putting locks on your luggage. If there is a place to leave your bags locked during the day, you should definitely take advantage of that. I have only had two things stolen (one of which was a very expensive watch*) but I know of others who were robbed of all of their belongings. If your bag is black –as many of them are- make sure to attach a nametag and other identifying marks (like a brightly colored scarf) to help keep it in your sight and to avoid accidental bag switches.

Let me note that the benefits of staying in youth hostels far outweigh any potential theft worries. Not only is it inexpensive, it's also a great place to learn from other travelers. Many hostels have gathering places, rooms that are equipped with a table, chairs, vending machines, a book swap and a computer. Standing on line to log onto the Internet, you'll have the opportunity for great conversation and learning about special local attractions.

*While showering, I placed my watch and clothing right outside the shower door and it was stolen. I thought it would be safe because of my proximity, but alas, I was mistaken.

Hostels

So far, I have only mentioned my experiences with European hostels but thankfully hostels are not limited to Europe or the distant reaches of the world. There are countless hostels right here in North America.

If you are a photographer and really want to capture the changing colors of fall in Vermont, you might be worried about the costs of staying in an expensive Bed-and-Breakfast. Do not fear; check out the following Vermont hostel:

Hotel/Hostel Coolidge
39 South Main Street
White River Junction, VT 05001
tel: 1-802-295-3118
website: www.hotelcoolidge.com
rates: $29

While most US hostels are very inexpensive, the hostels of New York City are (surprise, surprise) a notable exception. The current NYC rates are $35 for members and $38 for non-members, whereas most American hostels range from $12-18. That being said, the New York hostels are a great option when there just isn't enough room in your cramped studio for out-of-town guests. Hostels are still extremely cheap compared to hotels, and the yearly membership, at $28, is inexpensive (go to www.hiayh.org for more information, or while in New York, go to the New York International Hostel, as listed below).

New York International Hostel
891 Amsterdam Avenue
New York, NY 10025
tel: 1-212-932-2300
website: www.hinewyork.org
rates: $29-35
email: reservations@hinewyork.org

Important tip: Some hostels will accept reservations and if you can curb your spontaneity for a moment, I highly recommend it. I am not saying you should plan every step of a three-month trip, but if you are on a two-week timetable, you will really need to have a place to stay every night.

The "Cons" of Staying in Hostels

Some hostels have a "lock-out" period during the day, a strict window of time in which you cannot enter. On most days, this will not be a problem because you will be out enjoying the sights. Yet in the event that you are ill or want to escape bad weather, it can be a real pain to have to endure the "lock-out." If this happens, I highly suggest opting for a one star hotel.

In addition, hostels have strict curfews to which you must adhere. If they say you must be in before 11:30 pm, don't try their patience by even being one minute late. Once, I was in a small town in Italy and the Kirov Ballet was performing in a local *piazza* (public square). In order to avoid any problems

later on, I informed the people at the hostel that I would be home five minutes late. Well, their memories weren't serving them; because when I got back they weren't going to let me in. If I hadn't been able to speak Italian and explain my situation, I would have been stranded.

More Hostels

Here are some examples of hostels around the country that can be useful to various types of artists.

<u>Chicago</u>

Hostelling International – Chicago
24 E. Congress Parkway
Chicago, IL 60605
tel: 1-312-360-0300
fax: 1-312-360-0313
website: www.hichicago.org
email: reservations@hichicago.org
rates: $20-25

<u>Los Angeles</u>

Hostelling International – Los Angeles
1436 Second Street
Santa Monica, CA 90401
tel: 1-310-393-9913
fax: 1-310-393-5845
website: www.hilosangeles.org
rates: $26

Disney World Vicinity
Palm Lakefront Resort and Hostel
4840 W. Irlo Bronson Highway/Rte. 192
Kissimmee, FL 34746
website: www.hostelsweb.com
rates: $30

Miami
Miami Beach Hostel
1438 Washington Avenue
Miami Beach, FL
tel: 1-800-379-2529
tel: 1-305-534-2988
fax: 1-305-673-0346
website: www.clayhotel.com
rates: $28; private rooms: $38 for members and $44 non-members

Washington, DC
Hostelling International – Washington, DC
1009 11th Street NW
Washington, DC 20001
tel: 1-202-737-2333
fax: 1-202-737-1508
website: www.hiwashingtondc.org
rates: $26-29

New York City

The Hostel on 103rd and Amsterdam is a full service hostel. Pick up the free North American Youth Hostel guide. Go to www.hiayh.com membership $28 per year.

European Hostels

Italy

Villa Camerata Youth Hostel
Viale Augusto Righi 2-4
50137 Firenze, Florence
tel: 011-39-55601451
fax: 011-39-55610300
email: florenceaighostel@virgilio.it/ www.ostellionline.org
rates: about $15

Foro Italico – A F Pessina Youth Hostel
Viale delle Olimpiadi 61
00194 Roma, Rome
tel: 011-39-06-3236267
fax: 011-39-06-3242613
rates: about $15

The Beehive
Via Marghera 8
00185 Rome, Italy
tel: 011-39-06-44704553
email: info@the-beehive.com
website: www.the-beehive.com
rates: about $25 for dorm, $80 for private room

London

YHA Holland House
Holland Walk
Kensington, London W8 7QU
tel: 011-44-08707705866
fax: 011-44-20-73760667
website: www.yha.org.uk
rates: £21 pounds

Hemmingford House
Alveston, Stratford-upon-Avon
Warwickshire CV37 7RG
tel: 011-44-1789-297093
fax: 011-44-1789-205513
website: www.yha.org.uk
rates: £18 pounds

For actors, playwrights and theater fans, Stratford-upon-Avon is the place to be to encounter all things Shakespeare.

France

Relais International de la Jeunesse
26, Avenue Scudéri
tel: 011-33-049381276
rates: check for current prices

Hotel Tiquetonne
6 r. Tiquetonne, 2eme
Paris
tel: 011-33-142369458
fax: 011-33-142360294
rates: single $21 (shower $3), private $31
(check current exchange rates for the Euro)

This budget hotel is conveniently located near the famed Louvre museum. I also highly recommend visiting the beautiful Musée D'Orsay, widely considered the greatest Impressionist museum.

The Sri Lankan International Jewelry Seller

On a scorching hot, humid day in Rome, Italy, as the sweat poured down my face and back and saturated every bit of me, I ventured out from my $15-a-night youth hostel (The Beehive). As I was making my way to the Coliseum, I was energetically greeted with "*ciao, bella!*" by *ragazzi* (boys) of all ages riding on *motorini* (mopeds). I smiled back at them and bid them a "*buona giornata*" in a way that clearly communicated, "thank you but no thank you." I'm quite aware that a friendly "*ciao bella*" is just an entrance statement, a precursor of sorts for a love story to begin between an ardent Italian and The American *Bella Ragazza* (girl).

I continued on, and was approached by a young man on foot asking if he could accompany me on my journey. I explained that I was on my way to the Coliseum to go on a tour of the Catacombs (where Christians and martyrs of the Christian faith were buried, 20 minutes outside of Rome), so we walked together. As he spoke, the beginnings of a mystery/romance novel fell from his lips, but this wasn't the imagination of my mind tripping through a twisted novel plot, this was reality. Depti, my Sri Lankan walking partner, revealed to me that he was an international jewelry salesman.

I had never encountered one before, but thought he looked more like the Sri Lankan version of Brandon from "90210", Dawson from "Dawson's Creek", or one of the guys from the OC, than an international black market jewelry salesman. With his turned-up collar, bright white teeth smiling against deeply bronzed skin and that Ryan Seacrest "Hollywood" hair, I wasn't sure whether to believe my wide-grinned walking partner until he pulled from his pocket a rather large sapphire gem.

He assured me there were more gems to be seen and asked me if I would like to come and see the rest in his hotel room. I declined, as any wary, responsible American female traveler should.

One would think that the story stops there but it doesn't. Upon arriving at the Coliseum, I learned that my tour had been cancelled and I was greatly disappointed. Depti, however, had a solution: an air-conditioned car in which he could drive me to the Catacombs. For about 20 minutes we sat at the backside of the Coliseum discussing whether I should go with him, as I had just met him a little over 30 minutes ago. He told me to call his friend in Long Island, NY, as a reference to his good character. So I did; I dialed John in Long Island, who was waiting to catch a train and didn't have much time to talk, and was reassured that Depti was a good guy and that I had nothing to worry about. With that I took a beautiful, air-conditioned ride twenty minutes outside of Rome to one of the most fascinating places I have ever been. I am and always will be in debt to my dear friend Depti, the Sri Lankan black market international jewel seller.

Friends, Floors, Couches and Spare Bedrooms

Over the years, my artist friends and I have spent time sleeping on each other's floors and couches. I have found most artists are happy to extend their floor/couch/air mattress to another artist in need.

Recently, I visited California and had the awesome opportunity to stay with one of my theater friends. In Los Angeles, people tend to have much more space for much less money. My friend pays about $450 for a spacious room in a large house, complete with a fully equipped kitchen and a yard to boot. I stayed for a week in the guest room (yes, there is even a guest room) and paid nothing for this fun California vacation.

I've hosted guests in my own humble digs -artists visiting from L.A., London and Italy- and they were deeply grateful to have a place to rest their "tired tushes" before pounding the pavement. Some visitors who aren't artists, however, have been unimpressed with the inherent sacrifices that are part of the artist's life. One of my long time friends has a 2500 square foot house; I, on the other hand, reside in a 325 square foot apartment. She expressed her inability to live in such tight quarters, I understand as my mother's kitchen is bigger than my apartment.

Tip: When staying with loved ones, always be sensitive to their (subtle-or-otherwise) signals and if they want you to go, go! Spend the money on a hotel in order to keep the friend or relative.

Another Adventure while traveling...

A funny thing happened to me in my travels...I was living with a spontaneous, vagabond mentality and decided to go to Amsterdam (I didn't go for the usual reason, as I am not one to "inhale") without having a place to stay. I wasn't worried, figuring a worst-case scenario would have me sleeping on the train.

On my way, I met a large group of college kids heading for the same destination. After talking with them for a while and sharing that I didn't have a place to stay, one of the boys offered his floor for me to sleep on. I wasn't comfortable with the arrangement and when I asked one of the girls in the group if I could sleep on *her* floor, I was turned down. This was very different from what I was used to, as sharing rooms and hostels are a normal part of the backpacker's experience.

So here I was arriving in Amsterdam at 11:00 PM, destination-less, when I spotted a man on a red bicycle shouting, "room for rent!" He led me directly into the Red Light District and showed me to my small quarters above a bar. My "welcome" sign read, "When smoking anything, keep the windows open." Interesting décor aside, the place was safe and allowed me the spontaneous (but comfortable!) adventure I was seeking.

Travel Tips - Getting Ready

Once you have your flight and accommodations booked, here are some other important things to remember.

Travel-Related Credit Cards

If you fly a lot, get a credit card that is tied to an airline company or one that gives you reward points for travel and accommodations. The problem is that many of those cards have higher-than-usual interest rates. You get the points toward your flight but you are paying 18.9% interest. If you can find a card with points and can pay it off in full every month, then it is definitely worth having.

Paying Bills While Away

While traveling, you may have bills that come to your home. Ideally, you could have a family member, partner or trusted friend attend to them in your absence. Another option is to take advantage of the online bill-paying services (If choosing this setup, remember to ask the post office to hold your mail) that many companies now offer. Always alert all of your cards and companies to pay that you will be traveling. Also, make sure you have all of your passwords and that you have set up identify theft precautions.

Magellan's Travel Catalogue

I never travel without consulting this catalogue for my essential needs. (i.e. Pak it Compressors, film Protector)

If you are a professional photographer, you can avoid these machines by calling Globe Aviation Services Corporation at 1-817-528-2376. They can give you more information on film protection and tell you how to arrange a private screening to sidestep the radiation process.

More Money Tips

- Carry some money in the currency of your destination place.
- Bring more than you think you need, better safe than sorry.
- Give a copy of important financial information, account numbers and passwords to a trusted family member.
- Bring a Visa and an American Express card.
- Use Traveler's checks.
- Take American dollars to pay for a return bus/cab and airport food.

Ten Great Things To Bring on Your Trip

1. A really cool, super-duper hip Swiss Army knife

2. Small travel clock

3. Let's Go (a.k.a. the travel "bible")

4. Very good walking shoes

5. Spiral travel journal

6. Two bathing suits (For women, I advise bringing both a one and two-piece suit. For men, I suggest a Speedo for European travels, and also a longer pair of shorts.)

7. The best camera you can afford (You may never go to this destination again; capture it in the best way possible.)

8. Passport/document organizer – it keeps your money, airline tickets and passport all in one very handy organizer. (www.statravel.com)

9. Youth Hostel Card

10. Lightweight, supportive backpack or a bag on wheels. (Never use a suitcase unless traveling with a personal assistant and chauffeur.)

More Tips for Travel

DRINK WATER
Drink plenty of water before, during and after you travel.

USE LOTION
Take some lotion for your face and hands. Long flights can leave even the most youthful appearances in need of refreshing.

BREATH FRESHENER
Carry Listerine Pocket Packs™ or gum in case your toothbrush isn't handy.

BABY WIPES
It could be hours before your next shower, so baby wipes can serve as the next best thing.

EARPLANES™
These small, soft plastic earplugs keep you from feeling the pressure of take-offs and landings. If you suffer from sinus conditions, you will be forever thankful for these beauties.
(The Civilized Traveler, at 2003 Broadway @ W. 68th Street.)

SNACKS
Many airlines are not providing food, bring your own.

CHANGE OF UNDERWEAR
A change of clothing is ideal, but if it's not possible, be sure to carry a clean pair of underwear and a bathing suit if you are going somewhere with a pool.

DREAM TRAVEL PAGE

Taking time to dream is the first step to creating a new reality...

Where would I go if there were no limitations with time or money?

What would I bring with me? Books? A radio?

Would I bring anyone with me?

Would I create something or simply go to find peace and quiet?

ARTISTS - GENERAL

Associated Actors and Artists of America
165 W. 46th Street, Room 500
New York, NY 10036
tel: 1-212-869-0358

Artists Foundation
516 East Second St., #49
Boston, MA 02127
website: www.artistsfoundation.org

Artist Help Network
19 Springwood Lane
East Hampton, NY 11937
tel: 1-631-329-9105
website: www.artisthelpnetwork.com

New York Foundation for the Arts (NYFA)
155 Avenue of the Americas, 14th Floor
New York, NY 10013
tel: 1-212-366-6900, ext. 230
www.nyfa.oqqrg

College Art Association (CAA)
275 Seventh Avenue
New York, NY 10001
tel: 1-212-691-1051
www.collegeart.org

Artjob
1743 Wazee Street, Suite 300
Denver, CO 80202
tel: 1-888-562-7232
website: www.artjob.org

Arts Deadline List
www.artdeadlineslist.com

creativePLANET Communities
5700 Wilshire Boulevard, Suite 600
Los Angeles, CA 90036
tel: 1-323-634-3400
website: www.creativeplanetcommunities.com

ACTORS

Actors Equity Association (AEA)
165 W. 46th Street
New York, NY 10036
tel: 1-212-869-8530
website: www.actorsequity.org

American Federation of Television and Radio Artists (AFTRA)
260 Madison Avenue, 7th floor
New York, NY 10016
tel: 1-212-532-0800
fax: 1-212-532-2242
www.aftra.com

Screen Actors Guild (SAG)
360 Madison Avenue, 12th Floor
tel: 1-212-944-1030
website: www.sag.org

Actors Federal Credit Union
tel: 1-212-869-8926
www.actorsfcu.com

The Actors' Fund of America
tel: 1-212-221-7300
website: www.actorsfund.org

The Actors' Work Program
tel: 1-212-345-5480

Volunteer Lawyers for the Arts
tel: 1-212-319-2910

VITA Program (Volunteer Income Tax Assistance)
tel: 1-212-869-8530

The Social Service Department of the Actor's Fund
tel: 1-212-221-7300

The Motion Pictures Players Welfare Fund
tel: 1-212-221-7300

NYC Film Commission
tel: 1-212-489-6710

Dancers

American Guild of Musical Artists (AGMA)
1430 Broadway, 14th floor
NY, NY 10018
tel: 1-212-265-3687

Society of Stage Director and Choreographers
1501 Broadway, suite 1701
NY, NY 10036
tel: 1-212-391-1070

American Guild of Variety Artists (AGVA)
184 Fifth Avenue
NY, NY 10010
(212) 675-1003

Capezio Dance Theater Shop
1650 Broadway (@51st)
NY, NY 10019
tel: 1-212-245-2130
www.capezio.com

COMEDIANS

Caroline's
1626 Broadway (btw W. 49th and 50th Streets)
tel: 1-212-757-4100
www.carolines.com

Gotham Comedy Club
34 W. 22nd Street (btw 5th Avenue and Avenue of the Americas)
tel: 1-212-877-6115
www.gothamcomedyclub.com

New York Comedy Club
241 E. 24th Street (btw 2nd and 3rd Avenues)
tel: 1-212-696-5233
www.newyorkcomedyclub.com

Ranjit Souri/NYC
The Second City Training Center
1616 N. Wells St.
Chicago, Il 60614
www.secondcity.com

VISUAL ARTISTS

Graphic Artists Guild (GAG)
90 John Street, Suite 403
New York, NY 10038
tel: 1-212-791-3400
www.gag.org

WRITERS

Writers Guild of America East, Inc. (WGA East)
555 W. 57th Street, Suite 1230
New York, NY 10019
tel: 1-212-767-7800
www.wgeast.org

International Women's Writing Guild
Box 810/Gracie Station
New York, NY 10028
tel: 1-212-737-7536
website: www.iwwg.com

The National Writers Union
113 University Pl., 6th floor
NY, NY 10003
tel: 1-212-254-0279
website: www.nwu.org

Artist Trust
1835 12th Avenue
Seattle, WA 98122
tel: 1-866-21trust/1-206-467-8734
website: www.artisttrust.com

The Authors Guild
116 West 23rd Street, Suite 500
New York, NY 10011
tel: 1-212-563-5904
website: www.authorsguild.org

Funds for Writers
Website: www.fundsforwriters.com

LIFE COACHES FOR ARTISTS

The Creative Seed, Career and Life Coaching
P.O.Box 1082
Maplewood, NJ 07040
tel: 1-973-762-5871
www.thecreativeseed.com

PHOTOGRAPHERS

B & H Photo Video
420 Ninth Avenue (at 34th Street)
tel: 1-212-444-6615/1-800-606-6969
www.bhphotovideo.com

Calumet Photo
16 W.19th st.
NY, NY 10011
tel: 1-800-225-8638/1-212-989-8500
www.calumetphoto.com

MODELS

Models Guild
265 W. 14th Street, Suite 203
New York, NY 10011
tel: 1-212-647-7300
www.simplicity.com

Thanks Y'all!!!

Wow, there are so many people to thank. First, I have to thank God for taking me through the rough spots and showing me always the glimmer of hope even on a cloudy day.

The place where I was born, Norfolk, VA. Growing up in a relatively small town helped me to always see the people who were in front of me. I have to thank my mother who has always been there for me. I am a bit of a wanderlust and she is the one that helps me hold my life together. Thanks Mom and Ken for the last few days alone at your house with your computer. I want to thank my dad (CW), who lives in me and is constantly telling me to take risks. My grandparents Bubby and Vivian-for living a pure, simple life and showing me that our needs really are simple-good food, a clean house, nice looking economic clothes and a dependable car. Longwood University for taking an interest in every student. Dr.Nelson Neal and Tammy Tipton-Nay for paving the way to my dance career. Gwen Spear Meng at Old Dominion University. Sticking with your **very** challenging classes changed the course of my life. Thanks for the prayers of my trusted friend Kathryn. Hugs to the Wentworths!

New York City! In New York there have been numerous teachers that helped shape who I am, most notably Lisa Hopkins (jazz and tap), Frank Hatchett (ageless, timeless jazz teacher), Richard and Allison Ellner for making the best dance school in the world-**THE BROADWAY DANCE CENTER.** Alan Langdon, acting teacher at The Circle in the Square Theater School, for showing us that passion really matters in this world and we need not ever hide it. Bardy at the Royal Academy of Dramatic Arts in London, thank you for acknowledging my raw talent and helping it grow. Melissa Hart (voice) for teaching with her whole heart.

Adam, my best friend ever, I really don't know how I would have survived without you. Thanks for everything little thing you have done, even when you wrapped my boxes and the tape sound made me crazy (don't worry I am okay). Thanks for always believing in me. You know the copy of this

book is 100% free for you. Deanne Newkirk, a gifted actress, I keep waiting to see you break out in a big blockbuster movie. You showed me with your talent and drive why we create art in the first place. Sam, my pre-publication editor, who was far more than just a great computer user, (this book would have never happened without your computer skills), but also a friend and a great support. Thanks for not walking out when I was laying on the floor and crying. Thanks for being the ying for my yang and the feng for my shui. I know we learned a lot and I am glad I went with my instincts after receiving 400 responses on Craig's list. Thank you Rachael at Eemerge what a miracle that was! I want to thank the people that have kept the "moulah" flowing into my pockets: Encorenationwide, Very Special Events, DVCX Worldwide, and The Michael-Alan Group. The Cohen's-thanks for the refuge and good food. Becky, thanks for the work, we had so much fun! My focus group: Bonnie and Tom Detrik, Adam, Sam, China and Donna. Honest comments were greatly appreciated. Donna thanks for being my friend, thanks for all the laughs, especially when it comes to pointing out two of my greatest assets to strangers.

Grazie Italia! This country has helped make me who I am today. The official land of "The Gift of Gab." I want to thank C.J. Everett and the Spoleto Symposium/Creative Workshop. I learned "Create, let it all out, do not judge, always edit later."
Thank you Luca for your love and support.

Thank **YOU** for buying this book.

First Big Break, now it's time to Celebrate!

- Full Day at the spa*
- Dancing all night at your favorite club
- A weekend retreat studying your craft
- A summer share in the Hamptons
- A helicopter ride around Manhattan
- A weekend in London catching a show
- A week in the Bahamas
- A week visiting a friend or relative
- Helping out a friend or neighbor in need
- What would make you happy?

*Two great spas:
www.georgetteklinger.com, Ask for Angela for Facials.
www.bodyessentials.com, Dawn has done my eyebrows for 10 years.

If you would like to tell The Resource Girl what you think, please contact her at:

www.resourcegirl.com

Made in the USA
Lexington, KY
09 December 2009